B R I T A I N I N O L D P H

AROUND
FAREHAM
PAST & PRESENT

TIMOTHY ALLETSON SAUNDERS

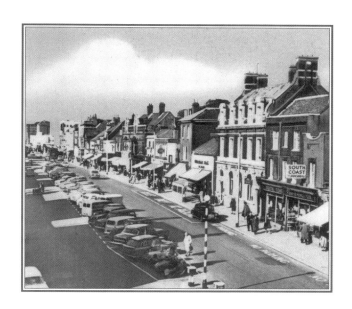

SUTTON PUBLISHING

Sutton Publishing,
an imprint of NPI Media Group Limited
Cirencester Road · Chalford · Stroud
Gloucestershire · GL6 8PE

First published 2007

Title page photograph: West Street,
1950s. (*Westbury Manor Museum*)

British Library Cataloguing in Publication Data
A catalogue record for this book is available from the
British Library.

ISBN 978-07509-4586-8

Typeset in 10.5/13.5 Photina.
Typesetting and origination by
NPI Media Group Limited.
Printed and bound in England.

To Caroline
For your love and support. In particular, thank you for your help and patience
when I took the photographs for this book and for proofreading the final drafts.

—————◆◆◆—————

The author William Makepeace Thackeray remembered the Fareham of his
youth as 'a dear little old Hampshire town inhabited by the wives, widows,
daughters of Navy captains, admirals, lieutenants'.

CONTENTS

FOREWORD

It is a privilege to write the foreword to this fascinating book which has brought back many happy memories. My first-born grandson has written another masterpiece. Fareham has always been close to my heart. It was in 1947 that I first became acquainted with its bustling streets and its happy residents. Being a naval man, I was based at HMS *Daedalus* at Lee-on-the-Solent for a time. Living at Alverstoke and later Stubbington, I always had an excuse to visit this fine town. The excuse was mainly that John Everard, a retired sickberth chief petty officer, had taken over the licence of the Bugle Inn in West Street. He was affectionately known as 'Honest John'. John thoroughly enjoyed his time behind the bar at The Bugle, taking pleasure in talking to the locals. I had some happy times in that pub, supping pints of Brickwoods ale and reliving the past. The Bugle was by far my favourite tavern in Fareham and not just because John occasionally gave me a drink on the house! The atmosphere was second to none; it was a good, traditional ale house. Today, it has been renamed the Brass Monkey. It is pleasing that having not visited Fareham for some time, it is easy to become reacquainted with it surprisingly quickly and there is still a pleasant relaxed feeling about the town. That cannot be said of many places these days. Little has changed in the High Street with its wealth of Georgian buildings still graciously lining the street. It still looks smart, and while West Street has suffered much upheaval since my time, there are still some old buildings. If you look carefully on the side of one of the shops, at the top is an old advertisement that has been lightly painted over but still preserved. If only the bricks of these splendid buildings could speak, what stories they could tell. These little observations give insight into the past. I hope you will agree that this book gives a fair, interesting account of Fareham and its businesses as well as considering local personalities who not only made a difference to Fareham but to the country, such as Henry Cort, Sir William Cremer and Arthur Lee.

For all that has happened to Fareham it is still a thriving market town. For those who rush here and there, who perhaps visit Fareham with one shop in mind, it is all too easy to pass historic buildings without giving them the attention they deserve. Our busy modern lives rarely give us time for reflection. This book gives the undivided attention that these buildings deserve. It has certainly brought back fond memories to me and I hope it will to you.

Lt Cmdr O.A. Saunders, MBE (mil.), MCIEH (rtd)

ACKNOWLEDGEMENTS

I am extremely grateful to Julie Biddlecombe, the curator at Westbury Manor Museum, who has kindly given me permission to use many old images from the museum's archives. I thank Julie's colleague, Julie Carter, who spent much time supplying me with these images. Without Westbury Manor's assistance this book would not be as interesting. I wish Julie Biddlecombe every success in her new job at Darlington Railway Centre and Museum. Simon Fletcher, my commissioning editor, has been helpful and supportive. My grandfather, Lt Cmdr O.A. Saunders, has helped by sharing his knowledge of Fareham and its surrounding areas with me and by writing the foreword. Lastly, I thank Caroline for her love, support and patience during this enjoyable yet testing project. The author apologises if anyone has been inadvertently omitted. Every reasonable effort has been made to trace photographic copyright holders.

Tim Saunders

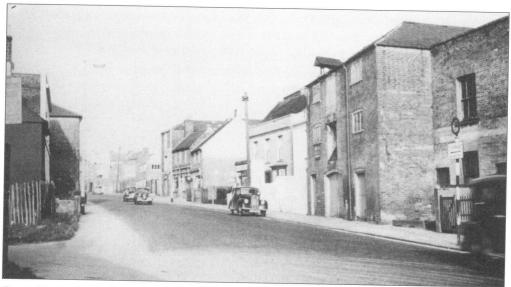

Quay Street, *c.* 1920. In September 2006 twenty-four one- and two-bedroom flats were being sold at Trinity Court, Quay Street, with prices starting from £127,995. Tesco has owned the derelict foundry site in Quay Street for a year now and it has become a blot on the landscape near the Market Quay centre. (*Westbury Manor Museum*)

Truffles Restaurant, High Street, Fareham, 2006. *(Tim Saunders)*

INTRODUCTION

By car, the often overlooked market town of Fareham is just fifteen minutes away from Park Gate and not more than five from Titchfield. From Park Gate there are two routes to take to Fareham: Junction 9 of the M27 and over the awkward Segensworth roundabout or a far more pleasant route via Wickham, through lush, rolling countryside. On a summer's day, a bike ride to Fareham is extremely rewarding.

Fareham's history dates back to the Norman era. It was originally known as Ferneham (now adopted as the name of the town's theatre). This thriving market town lies between the sprawling cities of Portsmouth and Southampton. In the past it was where naval officers chose to live because of its elegant streets and its close proximity to Portsmouth. The Royal Navy still operates from here with the Maritime Warfare School, HMS *Collingwood* which has trained many sailors.

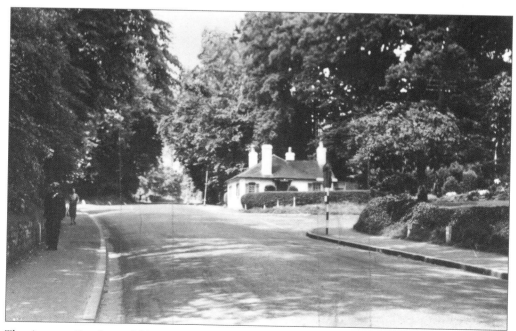

The Avenue, Fareham, 1920s. (*Westbury Manor Museum*)

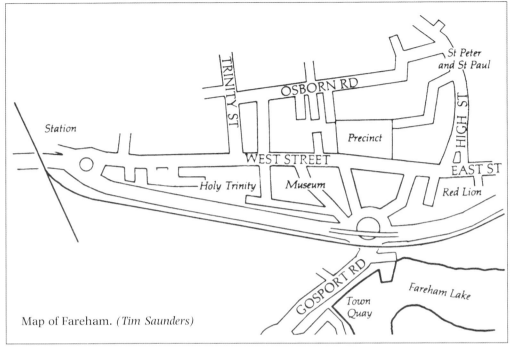

Map of Fareham. *(Tim Saunders)*

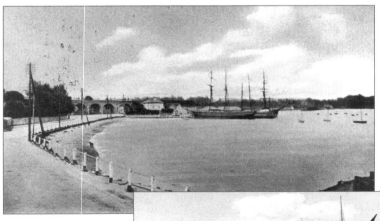

Fareham Creek, 1904. *(Westbury Manor Museum)*

Fareham Creek, *c.* 1911. *(Westbury Manor Museum)*

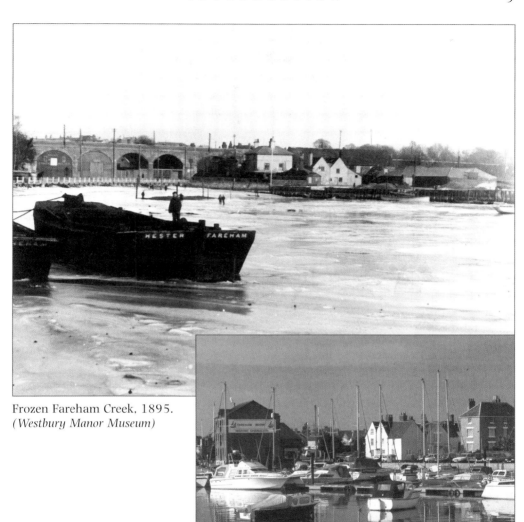

Frozen Fareham Creek, 1895.
(Westbury Manor Museum)

Fareham Creek, 1990.
(Paul Cave Publications Ltd)

The Domesday Book states that Fareham was held in demesne by the Bishop of Winchester. It had a church, two mills and a population of just fifty-two. Fareham was described by Leland in the 1540s as a 'fiscar village'. In 1638 John Wesley preached in the street here. By 1805 Bayley and Britton saw Fareham as 'a respectable and populous town, chiefly inhabited by persons employed in maritime occupations; and, indeed, indebted for its whole importance to the naval establishment at Portsmouth'. Handmade tiles from Fontley used to be loaded onto ships at Fareham harbour destined for Belgium.

By the beginning of the twentieth century Fareham had developed into a market town. As its population grew, so the town expanded. It is reasonable to say that most of the existing architecture in the town centre dates from around 1800 to the present day.

The port developed three quays: Upper Quay, Town Quay and Lower Quay. Commercial activity there continued until the 1970s. In the fourteenth century Fareham port became renowned for its wine trade and later dealt in other goods, which included bricks (from the numerous local brickworks), coal, corn and wheat as well as chalk from Portsdown Hill. Shipbuilding slowly became one of the town's principal trades, so much so that in 1403 a ship named *Marie* was built here for King Henry IV. Ships of up to 200 tons were built at Fareham and timber from here was exported to Chatham and other shipbuilding centres in the sixteenth century.

Other port activities included milling, salt making, rope making and electricity generation, which powered one of the earliest town lighting schemes in the country. As time passed there was an increase in naval activity and hulks were moored in Fareham Lake. There were 9,000 prisoners of war contained here.

In his *History of Hampshire* (1795), Warner wrote that 'Fareham was a pleasant town with a market on Tuesdays and a fair on 29th June. It has a well-endowed charity school where children are instructed to read and write so as to qualify them for useful employment in life. King Charles dignified this place with the honorary title of an earldom in creating Madame de Queroval, his mistress, Countess of Fareham. Cams, south-east of Fareham, is the elegant seat of the family of Delmé.'

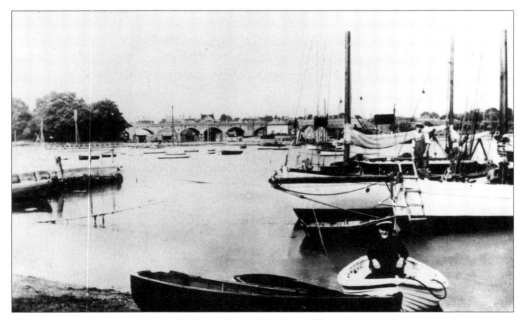

The Quay Fareham, early twentieth century. (*Westbury Manor Museum*)

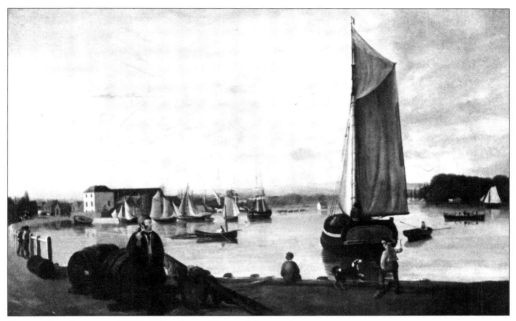

Port of Fareham, *c*. 1800. *(Westbury Manor Museum)*

In the mid-nineteenth century Fareham became an important railway junction from which strawberries grown in Sarisbury and Swanwick were transported around the UK. This resulted in the decline of the port. Today Upper Wharf is Fareham's last link with the sea. Marine-dredged aggregates are brought up Fareham Lake and are sorted in a grading plant on the wharf.

Fareham Flour Mill operated between 1830 and 1960 from its distinctive building at Lower Quay, now converted to residential use. Today the warehouse building is used for retail chandlery, marine brokerage and offices.

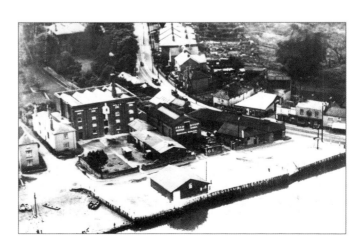

Fareham Flour Mill,
c. 1935. *(Westbury Manor Museum)*

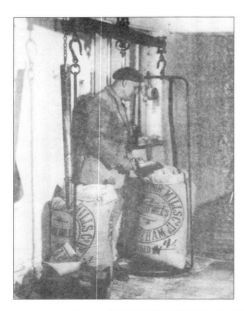

Fareham Flour Mill, *c.* 1900. This chap is weighing flour. His scales were made in about 1890. *(Westbury Manor Museum)*

Staff at Fareham Flour Mill, 1940s. In the middle of the front row is Mr Hilton Heaseman. On his left is Mr Schmidt, the foreman, and on his right is Mr Richards, the company secretary. *(Westbury Manor Museum)*

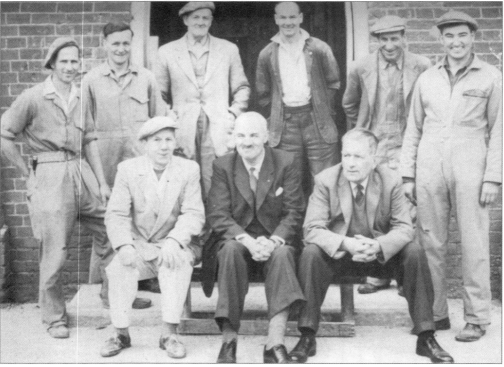

Fareham Flour Mill's original site was in Mill Lane but the building was taken down and the bricks were used in the new mill from where flour could be sent by boat. Unfortunately Mr Heaseman was forced to close the flour mill in 1960.

In 1801 Fareham was little more than a village with a total population of just over 5,700. Even so, it had its own cricket club, which had been founded in 1882. Sadly this faded out in 1902 when tenancy of the cricket field ceased. By 1901 Fareham's population had more than doubled to 14,123. One hundred years later the national census found that the borough of Fareham's population had grown by over seven times to a little under 108,000. Today Fareham has a similar population to Winchester, but not surprisingly is dwarfed by the likes of Southampton and Portsmouth – which have approximately 250,000 residents each.

Fareham used its clay soil for making bricks, chimney pots and tiles, as well as in the maritime industry. The town became especially well known for its Fareham red bricks. Probably the most famous use of these was in the building of London's Royal Albert Hall. Road names like Kiln Road indicate Fareham's historic past.

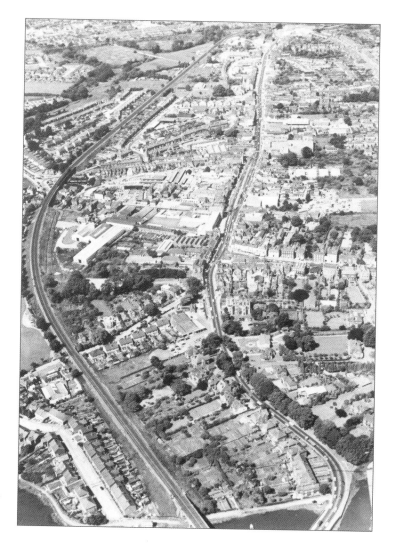

Aerial view of Fareham,
c. 1962. (Westbury
Manor Museum)

The town suffered during the Second World War and its worst bombing was on 10 and 11 March 1941, when Portsmouth and neighbouring harbour towns were bombed by the Luftwaffe.

In the 1960s Fareham was one of the areas highlighted for major expansion in the South Hampshire Plan, and there was huge development. Fareham can now stake its claim to being home to many examples of extremely poor architecture and new housing. Probably the best example of this is the borough council's offices, which tower over the town like some sort of evil demon. As you stroll along High Street enjoying the historic buildings, all of a sudden this shocking structure hits you between the eyes – if you dare to look too high above the classical roof lines. Its impact does not finish there: as you approach Fareham from the Portchester

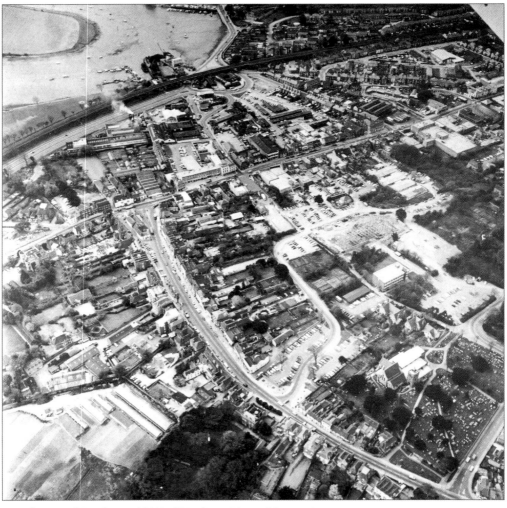

Aerial view of Fareham, 1974. *(Westbury Manor Museum)*

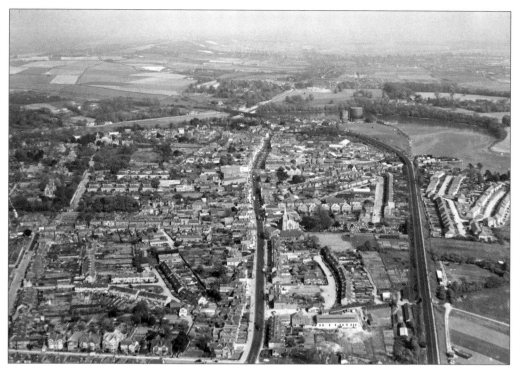

Another aerial view of Fareham, 1970s. The rolling green fields over yonder, although still present, have been encroached upon by new properties. It is apparent that Fareham has become more built up. *(Westbury Manor Museum)*

direction this blot on the landscape is clearly visible. There is no escape. Unfortunately many ill-thought-out and badly executed boxy commercial buildings were built at this time. However, Fareham's historic High Street stands firm. Long may it continue.

In the past five years it has been sad to see the borough becoming home to copious numbers of flats, thrown up apparently with little care. Profit is the priority. Lovely old houses are regularly being lost to new developments.

Perhaps Fareham's most famous association today is with the actor Tom Oliver who has brought worldwide interest to the town.

Tom Oliver lived in Fareham for fifteen years before emigrating to Australia and since 1988 has been world famous for playing the role of Lou Carpenter in the popular television series *Neighbours*. Born in London, he was bitten by the showbiz bug while still at school in Fareham, where he performed with the Fareham Festival Players.

Tom Oliver, 1980s. *(Paul Cave Publications Ltd)*

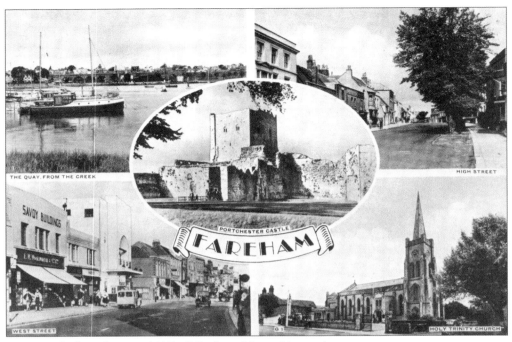

A postcard of Fareham, *c.* 1950. *(Westbury Manor Museum)*

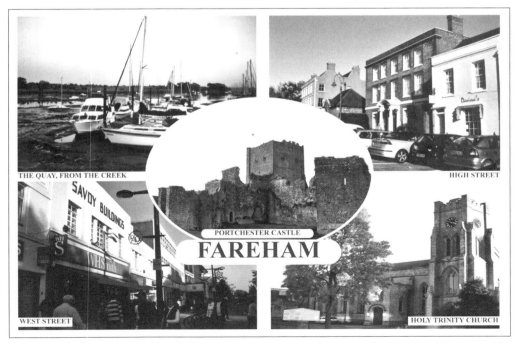

A postcard of Fareham, 2006. There are two major changes. West Street is now partly pedestrianised and poor Holy Trinity Church has lost its spire. *(Tim Saunders)*

For many years Betty Balfour-Smith has run a dancing school in the Fareham area and in a letter that was published in *Hampshire the county magazine* in December 1997 she recalled: 'Many years ago I, with some friends, was arranging a charity show at Fareham but was short of one young man. One of the girls volunteered to persuade her brother to fill the gap. Under some protest, he turned up to play several roles in the show. Since then he has travelled the world appearing in films, videos, television and stage successes – including pantomime. I am referring to Tom Oliver. . . Last September (a year ago) he telephoned me from Australia reminding me that it was my show many, many years ago that had set him off on a theatrical career. He has kept in touch since and is honorary patron of my dancing school.'

As with many towns in Great Britain, Fareham now relies on retail, which employs 15 per cent of the local population. Many have to travel to Southampton, Portsmouth and further afield for jobs. Call centres seem to have chosen Fareham as a popular location, because property is cheaper than elsewhere in the county. In 2006 a three bed semi-detached property in Fareham could have been purchased for under £150,000. The nearer to Southampton you travel, the more the property prices increase. A two-bed terraced house in Park Gate was recently advertised for £210,000.

There have been a number of previous books dedicated to the town of Fareham. While it is difficult not to cover some of the well-trod ground, I intend to consider individual buildings in detail as well as the businesses and individuals that occupied them to complement my first book for Sutton Publishing, *Southampton's Heritage Revealed*. Fareham is also a borough, which includes Hill Head, Park Gate, Portchester, Sarisbury, Stubbington, Titchfield and Warsash. The district was accorded borough status in 1972 and was reconstituted as a non-metropolitan district by the Local Government Act 1972 in 1974. As well as the town I am including some interesting outlying areas – Southwick, because it is a beautiful village near Fareham, and Lee-on-the-Solent, because it is a wonderful seaside town close to Fareham (and at one time was part of the Fareham borough). As already mentioned, arguably the most pleasant route to Fareham is via Wickham, which gives us an ideal excuse to briefly consider this quaint village. We shall start by looking at Fareham, and will then work outwards. It is intended that this book will ring the changes in Fareham as well as being informative and historically useful.

T.A. Saunders, 2007

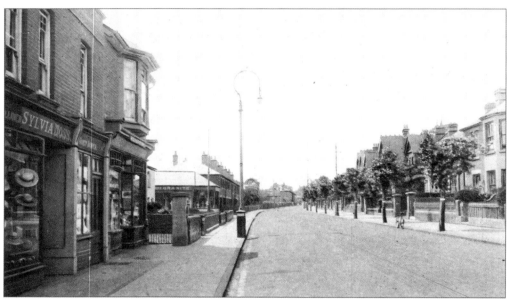

West End Fareham, *c.* 1930 *(Westbury Manor Museum)*

1

West Street

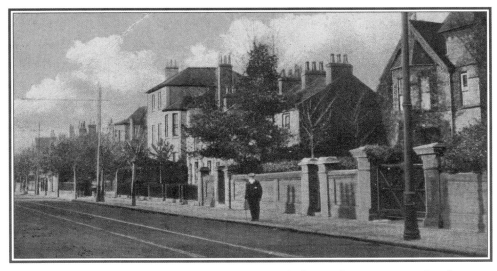

A nineteenth-century painting of West Street. We shall consider West Street first because
it is where all the shops are – it is the main heart and soul of the town and this chapter,
rightly so, is the largest in the book. This mile-long street still has a variety of shops
virtually from one end to the other. Before the First World War you could not move in
West Street on market days for crowds of people, animals, farm carts and wagons.
(Westbury Manor Museum)

Fareham market, 1970s. Today there is a mixture of buildings to be found in Fareham, pleasingly still including a few Georgian ones. Most, however, range from the nineteenth century to the present day. *(Paul Cave Publications Ltd)*

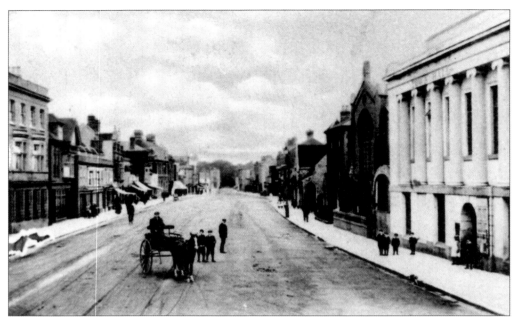

A postcard showing West Street in the late nineteenth century. At 2 to 4 West Street between 1935 and 1940 was Bennett & Righton Motor Dealers. *(Westbury Manor Museum)*

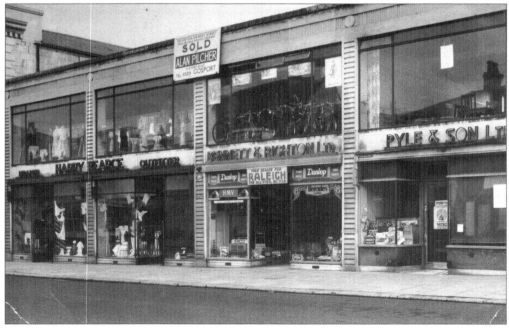

Harry Pearce, Bennett & Righton, and Pyle & Son Ltd, 1950. By 1950 it seems that Bennett & Righton were also cycle dealers. *(Westbury Manor Museum)*

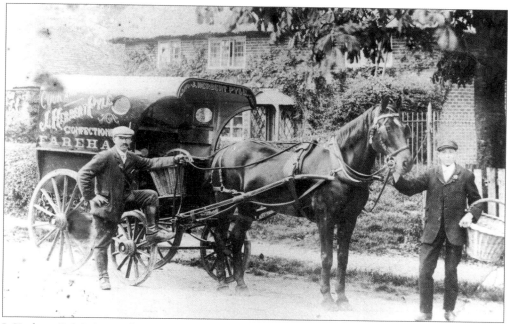

J. Herbert Pyle's horse-drawn delivery van, 1930s. One of the longest established businesses in Fareham could be found at 31 West Street. Paragon Bakery, run by Pyle & Sons, had traded here since 1899 and finally closed in 1970. During their long association with Fareham their various shops could be found at no. 98 from 1899 to 1923, no. 106 from 1940 to 1941, no. 141 from 1959 to 1960 and no. 159 from 1923 to 1940. There was even Pyle's Temperance Hotel at no. 161 from 1899 to 1923. *(Westbury Manor Museum)*

Lusby staff, 1930s. At no. 7 from 1899 to 1941 was W. Lusby & Son, a grocer who also made deliveries. *(Westbury Manor Museum)*

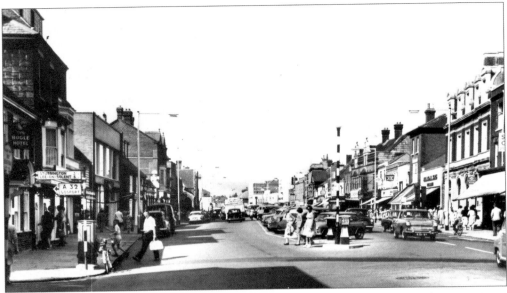

West Street, *c.* 1960. Some of the shops down the right-hand side of the street have awnings. A man strolls, hand in pocket, with his shopping bag. Is he contemplating a swift half in the the Bugle Inn? As the sun falls, shadows are cast. Lovely old cars line either side of the street. Three women all wearing dresses, the nearest to the camera wearing sunglasses too, are about to cross the road. All of this suggests that it is summer time. A bicycle, with the owner's jacket slung over the handlebars, rests on the pavement. These carefree postwar years did not require bicycles to be chained and padlocked when left unattended. Perhaps the bicycle owner is in the pub. Is the little boy darting towards the pub his son? Has the lad been sent on his mother's orders to drag his father back home? *(Westbury Manor Museum)*

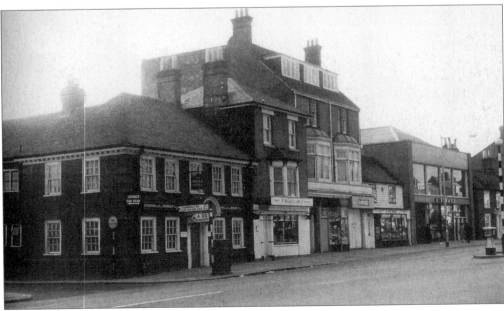

The Bugle and neighbouring shops, West Street, 1960s. *(Westbury Manor Museum)*

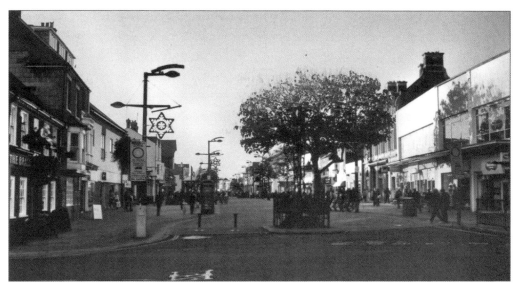

West Street, 2006. The area where the people are crossing the road in the earlier photograph is now pedestrianised and today a tree stands in place of the bollard and the 'keep left' sign. The Bugle Hotel still stands virtually unchanged but its name has been changed to the Brass Monkey. It is now a pub rather than a hotel. The signposts to the left of the old photograph pointing to Stubbington, Lee-on-Solent and Gosport on the A32 have been removed, because this street is now only one way to traffic coming into the town. The lovely old buildings on the right of the earlier photograph have been replaced by ghastly characterless postwar structures. How did the planners get away with this? *(Tim Saunders)*

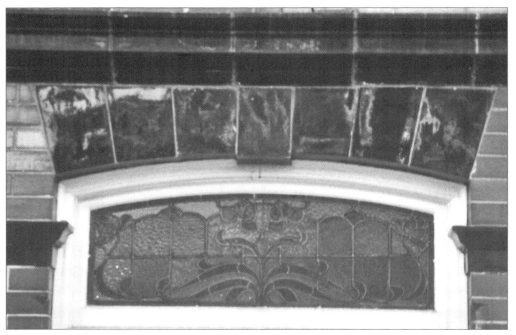

A detail of the art nouveau windows that grace the Brass Monkey public house, 2006. The tiles above the window still look fresh and appealing. *(Tim Saunders)*

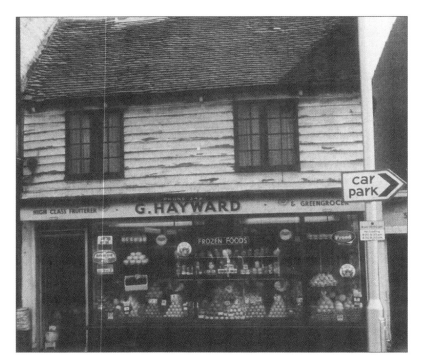

G. Hayward, the high class fruiterer and greengrocer, seen here in about 1900, has since disappeared. Birk's furniture store in West Street was established in 1912. *(Westbury Manor Museum)*.

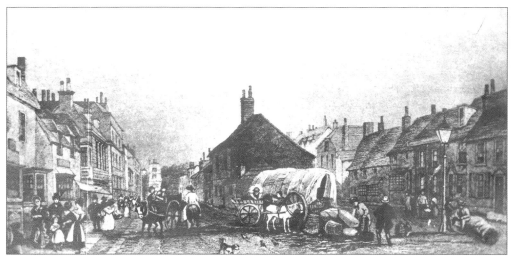

West Street, 1836. This painting shows a thriving, bustling street in the early nineteenth century. The eye is drawn to a well-dressed lady and gentleman who are either unloading their belongings or loading them on to the horse and cart. They have either just arrived and are checking into a hotel or boarding house over the road or vice versa. It's certainly a busy day and there's a little dog in the foreground. This painting shows that the roads in West Street were little more than dirt tracks. In 1923 the National Provincial & Union Bank Ltd was trading at no. 52. This became the National Westminster Bank in 1970. Between 1935 and 1940 W. Grafham, a cycle dealer, traded at no. 56. Between 1959 and 1960 D. Grafham, a hairdresser traded at no. 56b. It would appear that the Grafhams were related: were they husband and wife or father and daughter? *(Westbury Manor Museum)*

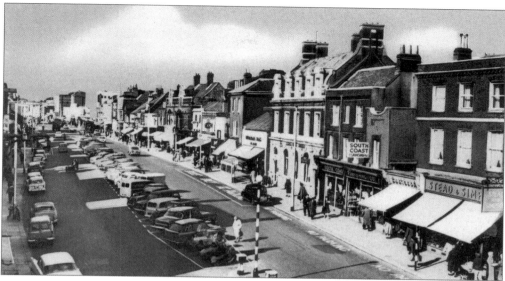

A postcard taken from a rooftop shows West Street, 1960s. In a scene where cars and motorcycles are neatly parked down the centre of the road and the shopkeepers have paid particular attention to the detail of their shopfronts, we see another snapshot of life in 1960s Fareham. It seems that the regal Rover 75 parked just before South Coast Furnishing Co. is in fact in a no parking area. But why not? The careful owner does not want to have his pride and joy scratched or dented. The Rover was advertised for many years as being 'One of Britain's Fine Cars'. It was in 1921 that the mascot found on the bonnet became a Viking longship in full sail, associating the car with Scandinavian Rovers of the ninth, tenth and eleventh centuries. Is the lady mooching across the road about to jump onto a moped and speed off into the distance? (*Westbury Manor Museum*)

West Street, 2006. There are few awnings above the shopfronts and Fareham's commercial centre has little character about it. Look up above the bland shopfronts of today and the tops of old buildings can still be seen. Today there are only about four buildings in West Street with any character to them. These are the Brass Monkey, the Warner Goodman & Streat premises, the Savoy Buildings and Westbury Manor Museum. Sadly many of the other buildings date from the 1940s onwards and were built for a purpose rather than with consideration for their surroundings. That said, some of the most recent buildings are passable as commercial premises, but will they still be standing in a hundred years? (*Tim Saunders*)

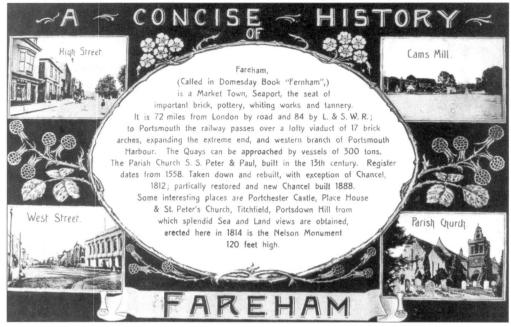

A concise history of Fareham postcard, 1930s. *(Westbury Manor Museum)*

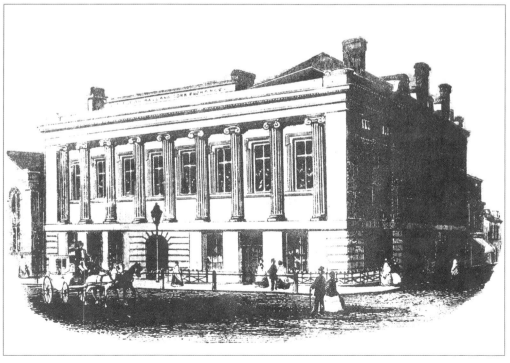

Institution Hall and the Corn Exchange February, 1861. *(Westbury Manor Museum)*

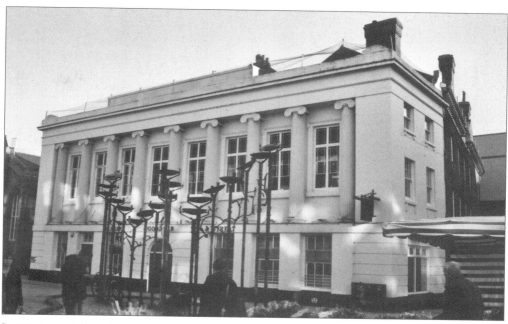

Institution Hall and the Corn Exchange, 2006. This fine example of nineteenth-century architecture with its Greek-style columns can be found at no. 66 West Street. The former Corn Exchange was originally designed in 1835 by the Portsmouth architects Jacob and T.E. Owen and extended in the same style later. The building is little changed today, though its surroundings are. The dapper gentlemen who once strolled elegantly along West Street have now been replaced by more relaxed, casually dressed folk. If this fine, imposing building could talk, the stories it could tell us. The staff of Warner Goodman & Streat are certainly fortunate to work here. *(Tim Saunders)*

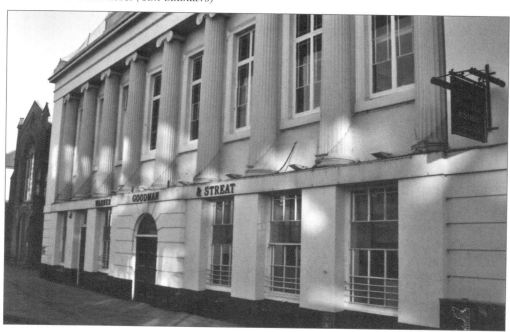

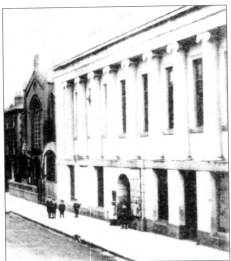

West Street, *c.* 1900. In 1878 D. Pargent, a saddler, traded at Institution Hall and the Corn Exchange but by 1899 the premises had been taken over by L. Warner, a solicitor. In 1923 the solicitor added his sons to the title, and by 1970 there was another name change to Warner Goodman & Co. Today the firm of solicitors is Warner Goodman & Streat, and is one of the longest established Fareham-based businesses. Other businesses have also traded from this enormous building. Between 1923 to 1959 Fareham & District Mutual Building Society was based here. In 1923 the Freemasons had their Lodge of Harmony here, and between 1940 and 1941 Portsmouth Savings Bank was based here too. This bank was absorbed into the TSB, which in turn was taken over by Lloyds. *(Westbury Manor Museum)*

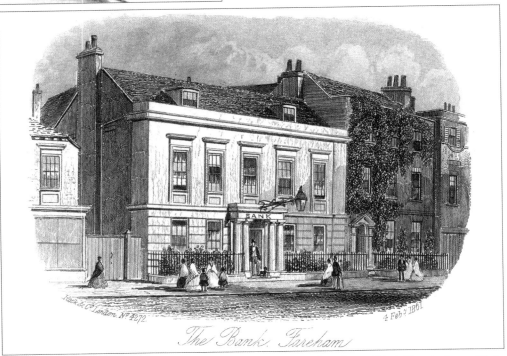

The Bank, Fareham

An etching of the bank, Fareham, 4 February 1867. Further down West Street at no. 81 in 1899 was the Wilts & Dorset Banking Co. This was taken over by Lloyds in 1914. From 1923 to 1960 Barclays Bank traded from here too. In 1899 J.T. See & Son, photographers, were based at no. 88. In 1935 S. Smith was trading from here. By 1959 it was the *Hampshire Telegraph & The News* office. From 1979 to today it has been the office of *The News* – the newspaper that covers Portsmouth and its surrounding areas. From 1878 to 1899 W. Pink & Son, coachbuilders and saddlers, were based at 113 and 114 West Street. It seems that the family drastically changed profession because from 1935 to 1960 W. Pink & Son, grocers, could be found at no. 94, while from 1935 to 1970 they had a second shop at no. 90. *(Westbury Manor Museum)*

Pink's impressive window displays, 1950s. West Street was home to sailors, tailors, milliners, chemists, butchers, cabinet-makers and no less than four watch and clock makers. Every trade you care to think of could be found here. How times change. *(Westbury Manor Museum)*

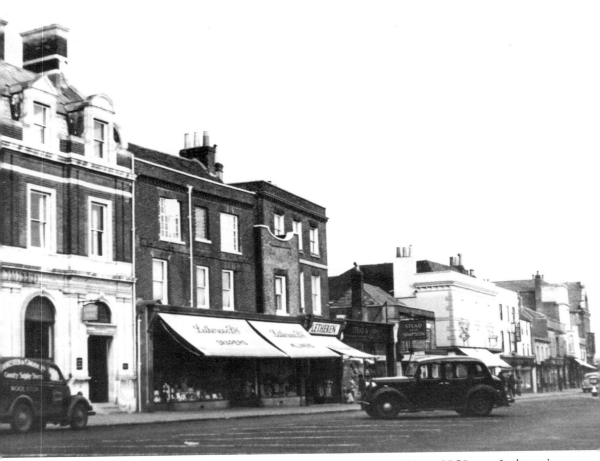

Letheren's drapers, *c.* 1950. At 39 and 41 West Street from 1923 to 1959 was Letheren's Drapers and Ladies Wear. It could also be found at 37a West Street from 1940 to 1941. During these years it seems to have been common practice for Fareham businesses to trade from a temporary second location – no doubt as a result of the bomb damage incurred during this dreadful period. It is therefore important to consider the devastation of the Second World War when we look at the buildings in and around Fareham, and be grateful that the town still has some wonderful historic properties.

Fareham's West Street was also home to some individuals with appropriate surnames for the occupation they pursued. For instance, at no. 93 between 1923 and 1960 G.H Winnett practised as a solicitor. He presumably won a reasonable amount of cases to continue practising for thirty-seven years. At no. 92 a timber merchant called Flippance & Co. traded from 1959 to 1960. One wonders whether Flippance was in fact flippant in his trading practices when he only survived for one year . . . *(Westbury Manor Museum)*

This sketch of Price's School shows the original school in West Street together with the master's house, 1721. *(Westbury Manor Museum)*

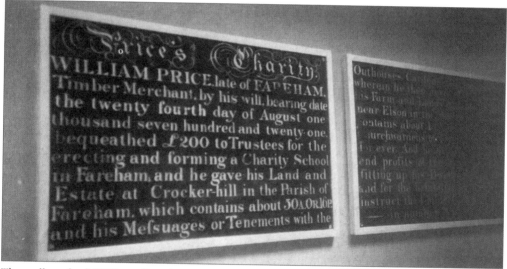

The college had William Price's will displayed by the entrance. It was in 1989 that these boards were saved when the buildings were demolished. They can currently be seen at the entrance to Fareham College. Not only did West Street have every shop imaginable, it also had a good school. Price's Charity School existed for the instruction and clothing of thirty poor boys of the Fareham parish. William Price was a rich philanthropic Fareham timber merchant. He died childless in 1725 and was buried in the family grave in the parish church of St Peter and St Paul. In his will of 1721 Price bequeathed his house in West Street, his estate at Crocker's Hill and his farm lands at Elson, Gosport, to the minister and churchwardens of Fareham who were charged with establishing a charity school for thirty poor children (fifteen poor boys and fifteen poor girls) to be 'instructed in the doctrines and principles of the Church of England' in Price's old family home in West Street. Price also stated that any surplus from the rents on his properties should be distributed among deserving poor widows of Fareham. The annual entrance exam was held on Ash Wednesday and entrants read from the Bible or a prayer book to the satisfaction of the vicar. In 1846 a new school was built in the same location in West Street. By the end of the nineteenth century the school was no longer able to compete with the new school, now also providing free education. Price's shut its doors in December 1901, transferring its remaining twenty-nine boys to the National School, which had opened in 1830 with just two teachers. *(Fareham College)*

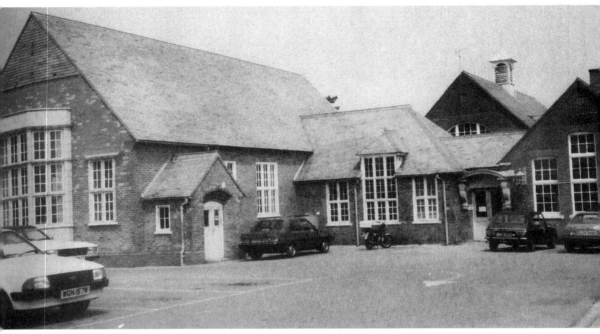

The new Price's School at Park Lane, built in the 1920s. A new school was to be built in Park Lane on a 10-acre site on the Uplands estate; it eventually became known as Price's College. The land cost £250 per acre and the building £8,385. Initially a new boys' grammar school, there was provision for 100 scholars, a master's house and dormitory accommodation for twenty boarders. The school opened in January 1908 with Stephen Bradly as headmaster. By 1920 there were 200 boys. The boarding and preparatory departments shut in 1948 and by 1970 there was a new teaching block and 700 boys, 160 of them in the sixth form. This was a prestigious school for Fareham with a good reputation. The student population of secondary schools in Fareham was projected to fall from 6,849 to 6,027 between September 1982 and September 1987, which meant that one secondary school was under threat of closure. In September 1981 Price's College had just over 1,000 full time students and Fareham Technical College just under 600, with 871 part-time and day release students. It was suggested that neither would be viable by the end of the decade and that a tertiary college would solve the problem. In a document entitled Price's College 1974–1984 written by the college principal, Peter Watkins, it was indicated that the closure of Bishopsfield School enabled the merger of Fareham Technical College and Price's sixth form, which took place in 1984. Fareham College took over the old Bishopsfield School site in Bishopsfield Road. There were thirty-three temporary classes on the Park Lane site and nine in a condemned building in Harrison Road. The college suffered from a serious lack of the specialist facilities required by a large sixth form college. (*Fareham College*)

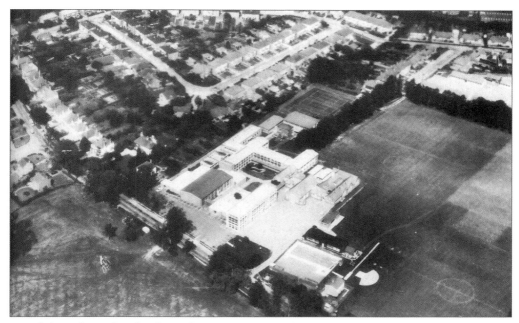

Aerial shot of Price's School, Fareham, 1980s. *(Fareham College)*

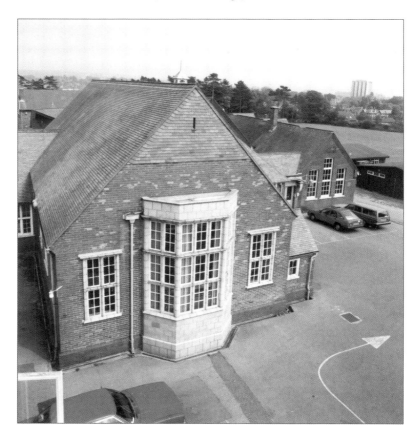

Price's School,
Fareham, 1989.
(Fareham College)

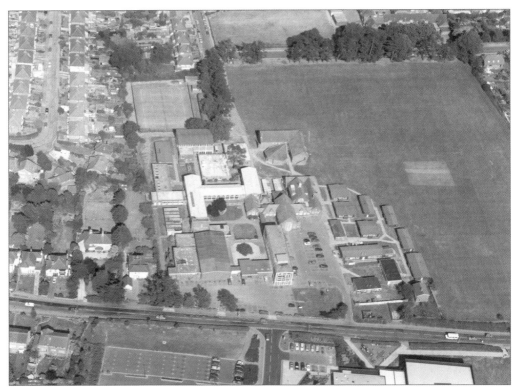

Price's School, 1989. In 2006 the Labour government, in an attempt to save money, proposed the closure of Fareham College and its merger with St Vincent's, and the opening of a new college in Gosport. *(Fareham College)*

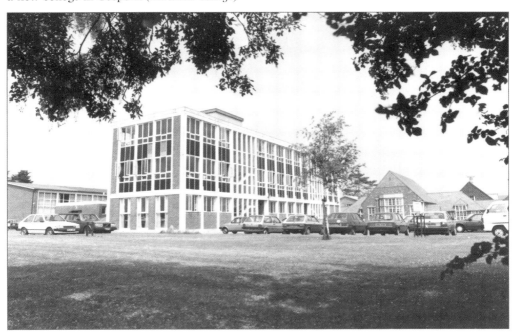

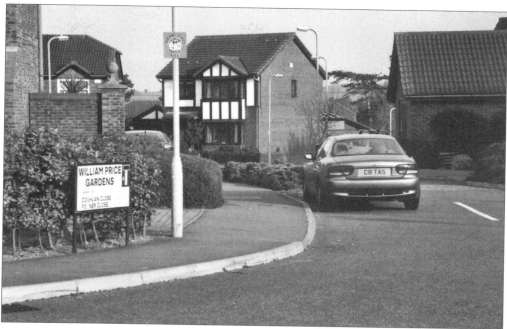

William Price Gardens, 2006. Another bland housing estate. It's such a tragedy that history can just be bulldozed and built on. In 1989 Redrow Homes started building a housing estate on the site – calling it William Price Gardens. The sale of the land should have helped to fuel the college coffers. A leisure centre was built almost opposite this development. (*Tim Saunders*)

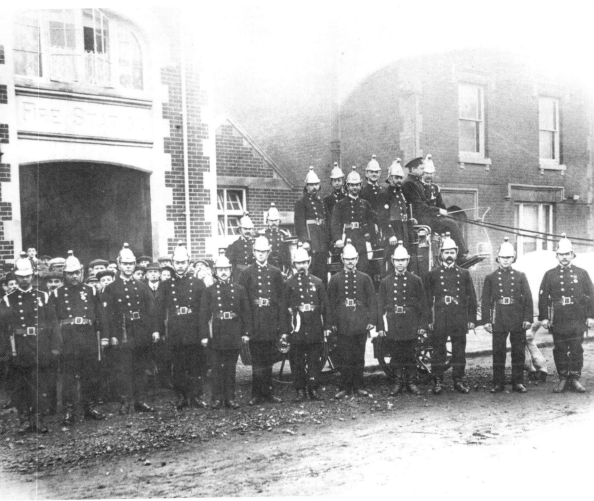

This photograph shows every member of the Fareham Fire Brigade on 17 January 1911. The chief officer was Mr Sutton. Interestingly Fareham was home to a Sutton stationers (no relation to the publisher of this book), but it is likely that Mr Sutton could have been related to Fareham's Sutton stationers.

Fareham fire station opened in West Street in 1911. As a result of local government reorganisation, the number of fire brigades in the UK were reduced by the amalgamation of various fire authorities. This resulted in the formation of the Hampshire Fire Brigade on 1 April 1948. From this date Hampshire County Council was required to establish a fire brigade for the whole of Hampshire with the exception of the county boroughs of Southampton, Portsmouth and Bournemouth which, as independent fire authorities, were required to establish their own fire brigades. When the planning commenced in 1947 the geographical area of Hampshire was known as the county of Southampton. The Hampshire Fire Service was divided into four operational districts (later re-designated divisions) each with a district headquarters (based at Aldershot, Fareham, Winchester and Lyndhurst), working to a county headquarters in Winchester. (*Westbury Manor Museum*)

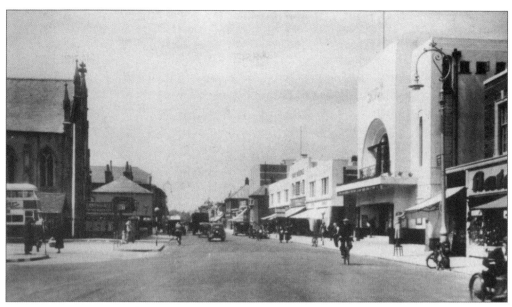

West Street, 1930s. The Savoy cinema was built in 1933; it had an extremely good restaurant. When the cinema closed it became the entrance to Fareham's bland, uninspiring shopping centre. Such shopping centres offer the opportunity to visit a number of shops under one roof: you don't get wet on a damp day, but the trouble is that you could be anywhere. It is not just the author who believes this shopping centre is dull and dismal because a planning application is afoot to drastically alter its appearance. Rumour has it that a well-known national department store wishes to have a Fareham presence. Could it be Debenhams, John Lewis or House of Fraser? *(Westbury Manor Museum)*

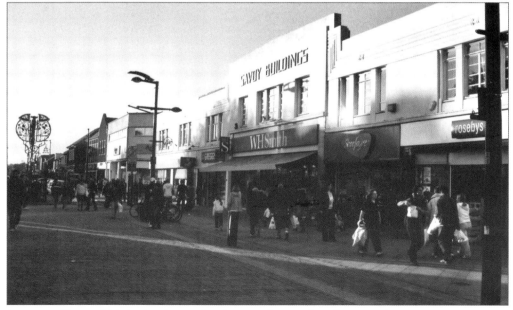

Savoy Buildings, 2006. This has to be the grandest trading location for a shop in Fareham. *(Tim Saunders)*

Savoy Buildings and its next door neighbours, 2006. Woolworths has moved into the ugly 1960s building to the right of Savoy Buildings. *(Tim Saunders)*

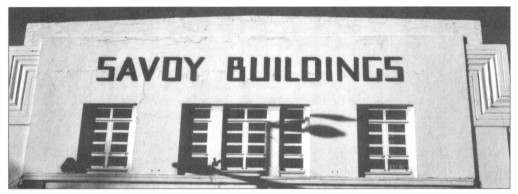

Detail of Savoy Buildings, 2006. What attention to detail. Quality workmanship like this is rarely found in Britain these days. Are those Crittall steel-framed windows we spy? Crittall has been producing windows since the late nineteenth century. Why can't all shops and supermarkets be designed to be aesthetically pleasing? Does good architecture cost so much more? This fabulous art deco building must have been built in 1935 because there is no recorded trading before this date. From 1935 a number of businesses have traded from these premises including: Currys (1960–79), Chapman's Laundry Receiving Office (1935–60), Dewhurst, butchers (1935–9), C. Codsen, chemist (1935–60), Harold's, hairdresser (1935–60), Jasper's Gowns (1935–41) and F.W. Woolworth & Co. (1935–79).

Frank Woolworth, an American, pioneered the new mass production that was to revolutionise retailing across the world. He opened up many types of product to ordinary working people from gold rings to pic'n'mix sweets. He built a multi-million dollar fortune and a chain of more than a thousand shops in two continents. He died aged sixty-seven in 1919.

Other businesses that traded here were the Savoy cinema (1935–70) and Smith & Son, stationers (1979–present) and the Singer Sewing Machine Co. There are few if any Singer sewing machine shops remaining in the UK today, although Singer does have an English website. It was in 1855 that Singer became the world's largest sewing machine company. It quickly began overseas expansion, starting in Paris, making Singer the world's first international company. *(Tim Saunders)*

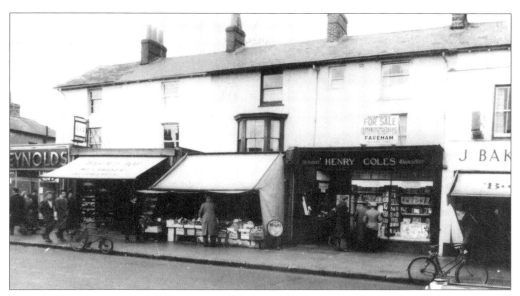

Harold Jobs, West Street, 1940s. At no. 97a was H. Job, watchmaker, who traded there from 1923 to 1935. From 1940 to 1970 H. Job, now a jewellers, could be found at no. 137 West Street. Parkhouse & Wyatt took this shop over in 1979. Today Parkhouse & Wyatt are trading in Southampton but not in Fareham. To the right of Harold Job's shop was a fruit and veg shop and to the right of this was Henry Coles the bookseller, which was up for sale. (*Westbury Manor Museum*)

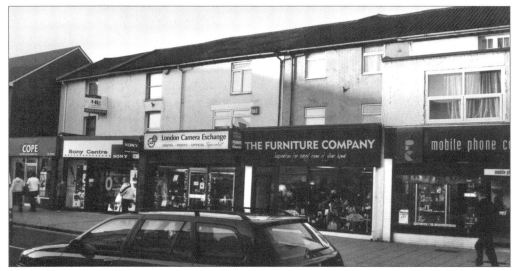

West Street, 2006. Reynolds is now a Scope charity shop. When charity shops move in, the area seems to become less prosperous. They get reduced council rates and many traders feel this is unfair. The Sony Centre is where Harold Jobs used to be and the London Camera Exchange has replaced the fruit and veg shop. Henry Coles' premises is now home to the Furniture Company and J. Baker has become the Mobile Phone Centre. At 15 West Street was Batchelor's, the town's chemist, which closed in 1977 after 200 years of trading. Mr Strugnell the candlemaker had a shop near the chemist. Dunn's the gent's tailor could also be found in West Street. (*Tim Saunders*)

The post office, *c.* 1910. Fareham's post office has been in several locations. In 1935 it was based at 204 West Street. From 1940 to 1959 it was at no. 109 and it then moved next door to no. 111 where it traded from 1959 to 1979. Today it can be found in an incredibly unappealing building at 117 West Street. Never has there been a more important time to support the Post Office. If it is consigned to history we will lose a worthwhile resource. *(Westbury Manor Museum)*

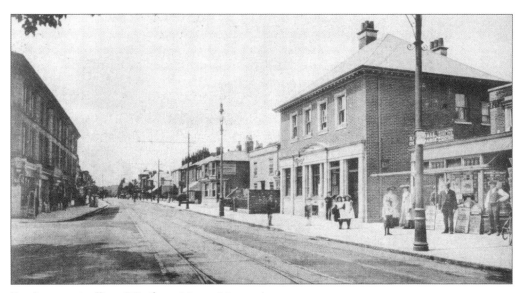

Fareham post office. *(Westbury Manor Museum)*

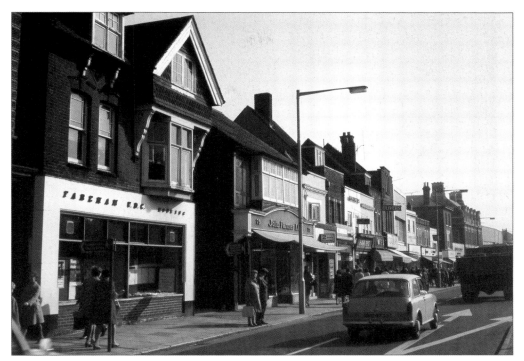

West Street, 1960s. There are certainly a lot of people about. At 73 and 75 West Street is the John Farmer shop, which from 1899 to 1959 was Pullen bootmakers. The shop was then taken over by John Farmer Ltd, who continued to run it as a shoe shop and traded from 1959 to 1979. *(Paul Cave Publications Ltd)*

West Street, 2006. Fareham has had a one-way system for many years now and it can cause much aggravation. In the 1930s the spire of Holy Trinity Church dominated the roof tops of West Street. On the right-hand side of the street many naval officers or retired officers occupied the terrace houses. Not surprisingly it became known as Admirals Row. Unfortunately many of the older properties are shabby these days. A lick of paint could make such a difference. In 1982 Waters the fishmonger, who had been trading in West Street, closed after three generations. *(Tim Saunders)*

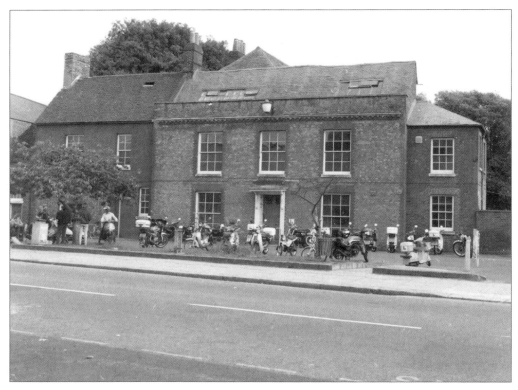

Westbury Manor, 1970s. The building looks in need of a bit of tender loving care. Outside there are plenty of 1970s mopeds. Some have L-plates, suggesting that this might have been the local motorcycle training school. *(Westbury Manor Museum)*

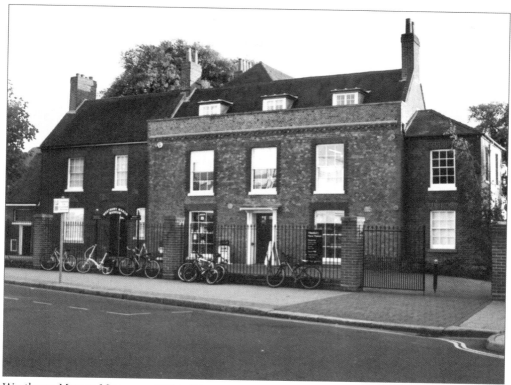

Westbury Manor Museum, 2006. There are some noticeable changes. The roof that clearly needed much repairing has been restored. A new chimney has been built on the far right. Chimney pots have been added to the far left chimney. Three roof windows have been built to allow good use of the attic space; this is now home to the Fareham archives. The light has been removed from above the top middle window. A sturdy iron fence has been erected around the perimeter with brick pillars that match the main building. Trust cyclists to put this fence to good use.

The late Georgian Westbury Manor was transformed into Westbury Manor Museum in 1990. Previously home to a succession of admirals, it was for over 200 years the offices of the stewards of Fareham Manor and later the home of Fareham Urban District Council. Today Westbury Manor Museum has superb local history displays covering Portchester, Titchfield and Fareham, and is an extremely worthwhile local resource. There are also regular temporary exhibitions and it is easily one of Hampshire's best town museums. Westbury House used to be opposite. Its gardens had a tennis court and a great mulberry tree. It is hard to imagine this today, as part of the site is occupied by fast-food chain McDonalds. *(Tim Saunders)*

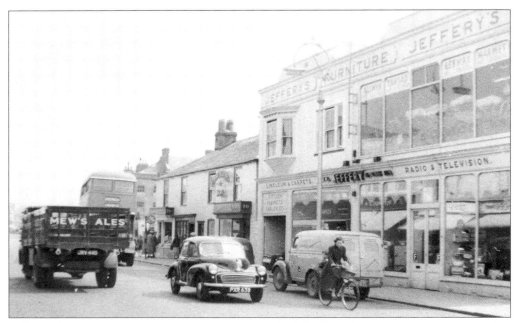

Jeffery's furniture store, West Street, *c.* 1955. To the left of Westbury Manor Museum used to be Jeffery's, which was pulled down in 1993. Heading down the street is a Mew's dray lorry – a familiar site at this time. Mew Langton & Co. was a brewery based in Newport on the Isle of Wight. A take-over of Mew Langtons by Strongs of Romsey went horribly wrong when Strongs itself was taken over by Whitbread. (*Westbury Manor Museum*)

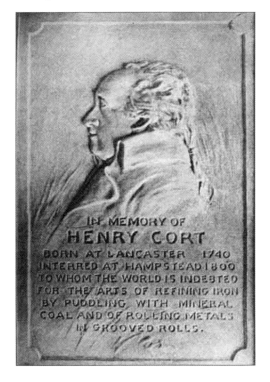

Henry Cort's gravestone at Hampstead. It is thanks to Henry Cort that Great Britain can produce its own iron. Until he came along, Britain bought iron from Sweden and Russia. Cort, who lived in Gosport, had an ironworks at Funtley on the outskirts of Fareham and played a major role in the industrial revolution. Until Cort, British iron was too brittle and full of impurities, making wood more reliable to build with. In 1775 Cort began a period of experimentation at Titchfield. (*Westbury Manor Museum*)

Henry Cort lived between 1740 and 1800. By the age of 21 he was in partnership with William Batty, an agent dealing in naval affairs. Most naval business at that time was carried out by independent agents working on commission. When Batty retired, Cort took over the agency.

England's superiority at sea depended upon well-built ships and many came from Solent dockyards. Strong mast hoops, anchors, pulleys and chains were needed but English wrought iron was not reliable enough for their manufacture, so it had to be imported. William Attwick & Co. of Gosport had been a supplier to Portsmouth Dockyard since 1722. By 1751 the business was in the hands of the founder's youngest son, William. Cort's agency became involved in the supply of iron to the Navy, and in 1768 he married Attwick's niece. Cort's agency supplied the Navy with products from the Attwick family forge. In due course he gave up his agency in order to operate the ironworks at Funtley (the ironworks had been in operation for almost 200 years by this time, having been initially the property of the Earl of Southampton). Henry enhanced the Funtley iron works (pictured) to make a wider range of items, and although the profits were reasonable, they were not sufficient to cover the investments. In 1780 a large sum was still owed to Cort.

At this time ships' stores were packed in traditional wooden barrels held together by iron hoops. In 1780 Commander Kirk of the Victualling Office asked Cort whether he could make these iron hoops. Cort replied that he could make them with forge hammers, but had no mill. He believed that the River Meon at Funtley would provide enough water, where a mill could be erected. The commander agreed that Cort should establish a manufactory of iron hoops for the government to bring down the artificially high price of iron. Cort stated that he was willing to erect a mill and he entered into a contract, starting in October 1780. During the Battle of Trafalgar in 1805 these were to be delivered to Portsmouth Dockyard at £21 per ton. Cort erected his mill at considerable expense and soon after the commencement of the works, requiring an increase of capital, he entered into negotiations with Adam Jellicoe, a Pay Clerk at Portsmouth. Cort became indebted to Jellicoe for several thousand pounds, advanced to fund Cort's operations. It is believed he thought the funding had come from an authorised source. Cort also agreed to employ Jellicoe's son, Samuel.

The naval authorities placed contracts for the hoops. Up until then almost all iron for naval use had been supplied by one contractor, Anders Lindgren, who imported it from Oregrund in Uppsala, Sweden. Other ironmasters took an interest in the process, and Cort asked them for 10s per ton royalty for the use of the patented process.

Meanwhile, Jellicoe was asked to explain his private investment of public funds from the Navy pay office, the £27,000 that he had lent to Cort. Investigations into Jellicoe's financial position revealed that he owed his employers nearly £40,000. When they failed to recover the debt they seized the Cort and (Samuel) Jellicoe business, leaving Henry Cort penniless. Unfortunately for Cort, Jellicoe had pledged Cort's patents (for his 'puddling method' for producing iron and a new rolling machine to speed the profiling of iron into wire, rails and strips) as security. These were seized by the Crown and subsequently valued at just £100. Cort spent his last years in poverty. It was only after an appeal to William Pitt that he received a state pension of £200 a year from 1794. The petition accompanying the appeal referred proudly to him as 'the father of the British iron trade'. At this time England had embarked on its long series of wars with France and Cort's innovations contributed towards the eventual English victory. Cort died in 1800 having struggled to support a wife and twelve children on his state pension. *(Westbury Manor Museum)*

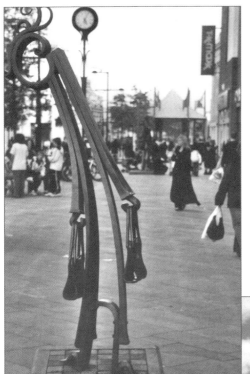

One of the iron sculptures in Fareham town centre, 2006. It depicts a man and woman carrying shopping bags. To celebrate the millennium, Fareham launched the Henry Cort millennium project. Thirty-four artists were interviewed and sixteen were accepted to produce a variety of iron sculptures in the town centre. Examples include the western marker which is based on the smith's tree of life that many ancient people considered an object of worship. This was made by Edward Fokin from St Petersburg. There is also a horn of plenty and a play feature, created by Andy Frost from Southampton. The railings of this were made by Peter Clutterbuck from Southsea. Westbury Manor Museum was instrumental in this project and ran an exhibition about Cort alongside it. (*Tim Saunders*)

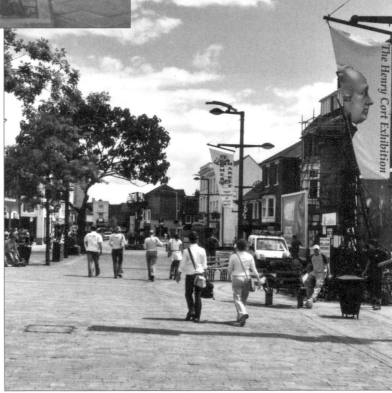

The Henry Cort millennium exhibition, 2003. (*Tim Saunders*)

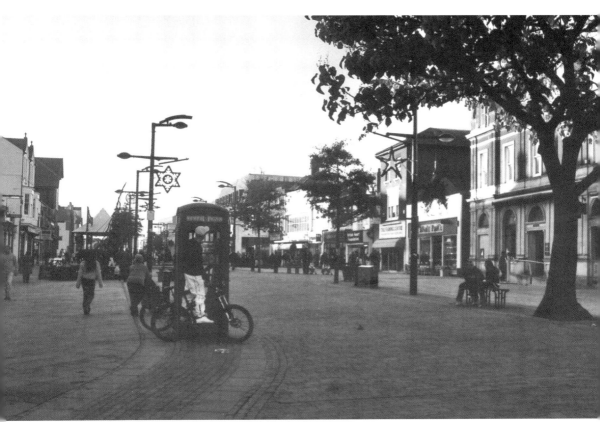

Culprit caught on camera, 2006. A youth wearing a baseball cap stands on his bike, leaning up against the red telephone box as he admires his handiwork. If you look carefully, you can see he has stuck a 'B' over the 'P' of TELEPHONE giving TELEBONE – of course 'dog and bone' is rhyming slang for telephone. Today there aren't many traditional red telephone boxes left now, partly because of vandalism. In this age of mobile telephony it is important not to forget the red telephone box. This memorable structure was designed in 1924 by Sir Giles Gilbert Scott, who is also credited with designing Waterloo Bridge and Battersea Power Station. It was in 1935 that the red telephone box was issued to almost every town and city in the UK to commemorate the silver jubilee of King George V.

According to British Telecom there are over 75,000 such loss-making boxes in the UK. Each box costs approximately £2,000 a year to maintain and it has been suggested that turning them into mobile phone masts would generate an income. After privatisation in 1996 British Telecom began to replace the cherished red box with a characterless modern equivalent. Scott's original telephone box can still be viewed by visitors to the Royal Academy in London. (*Tim Saunders*)

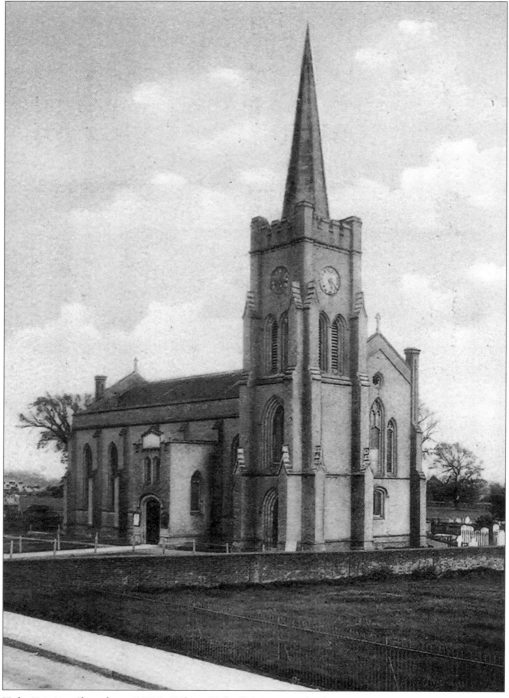

Holy Trinity Church, *c.* 1912. When Holy Trinity was built in 1835, it was on the edge of Fareham. As the town grew, it became quite central. Holy Trinity is the town's second church built to the design of Portsmouth architects Jacob and Thomas Ellis Owen. *(Westbury Manor Museum)*

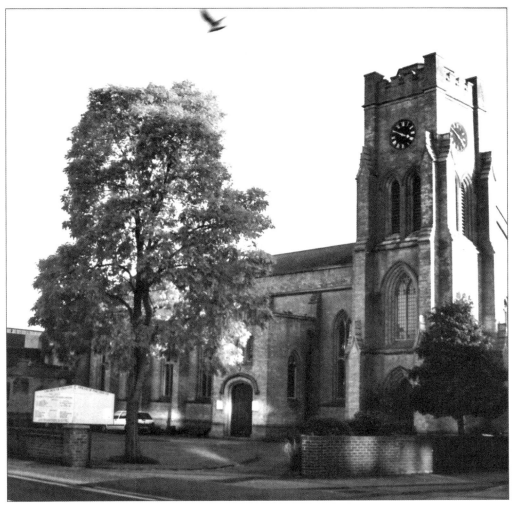

Holy Trinity Church, 2006. The most striking difference is that today there is sadly no spire. Lack of funds for restoration meant that demolition was the only option. *(Tim Saunders)*

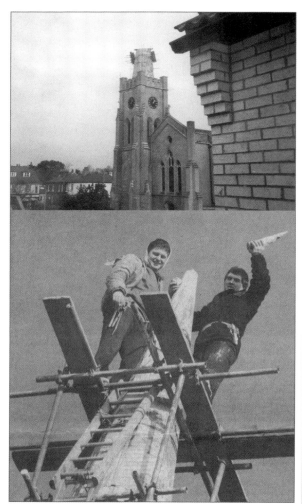

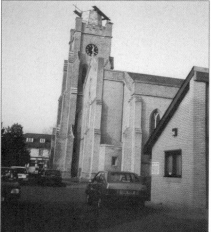

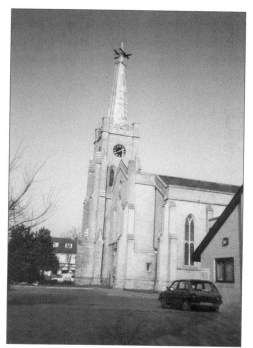

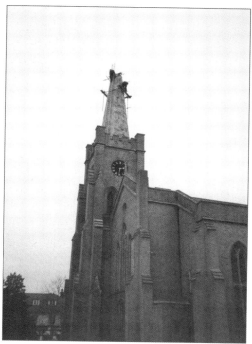

These photographs show the spire, which was added to the church in 1847, slowly being removed. It used to be a landmark for boats coming up Fareham Creek. In 1992 it would have cost between £50,000 and £150,000 to repair. Newspaper reports at the time stated that salt blowing off the sea had caused so much erosion that about 30 per cent of the thickness of the original stonework on the spire had gone. Although the gales in 1987 and 1990 had not affected it, the council condemned it and it had to come down. Sadly, the parishioners were unable to raise the money for repairs even though they had raised £40,000 to renovate the church in 1985 for its 150th anniversary. In March 1992 a newspaper article read: 'A flagpole is to become a temporary replacement for the demolished spire of a Fareham church. The flag of St George will be hoisted up the 20ft pole at Holy Trinity Church in the town's West Street on high days and holidays while church officials investigate a more permanent replacement.' Over fourteen years have passed and it seems that the funds are still not available to restore the church to its former glory. We should however, be grateful that Holy Trinity Church is still a church and not a mosque or restaurant, like some other fine Hampshire churches. Looking around the county, there are a great many churches that seem to have lost their spires. Many are left with flagpoles. Is this just a Hampshire phenomenon? *(Top, left: 1992, Mrs Westbrook)*

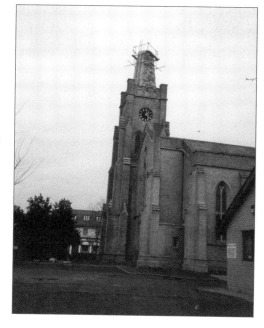

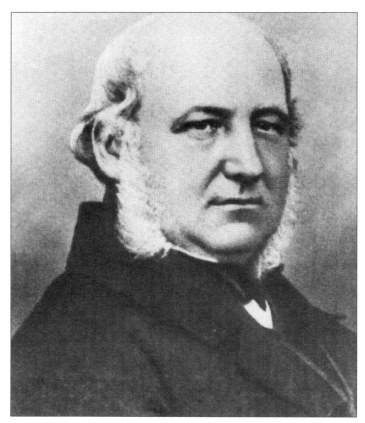

Thomas Ellis Owen is credited with building much of Southsea. Born in 1805, he lived a short life, dying in 1862. Son of Jacob Owen, a civilian engineer who worked for the Royal Engineers Ordnance Department in Portsmouth but also had a private architectural practice, he trained as an architect in London and Italy. Thomas was the architect and developer responsible for many of the buildings in both Portsmouth and Southsea. He was a thrusting entrepreneur who was a speculative builder, trained architect and local politician. He designed and built 106 villas and 54 terrace houses in Southsea as well as St Jude's Church in central Southsea. In addition to his work as an architect and developer, Owen was a prominent civic figure. He became mayor of Portsmouth twice (in 1847 and 1862) and also served as a magistrate.

Thomas Ellis Owen was inspired by the Regency architect John Nash, who lived from 1752 to 1835. It is easy to see why. Nash, with the backing of his sponsor the Prince Regent, developed Marylebone Park and the surrounding areas – the present Regent's Park, Trafalgar Square, St James' Park, and Regent Street. In 1925 the Prince Regent commissioned Nash to convert Buckingham House into a palace, but the prince died before work was finished. Nash was finally dismissed from the project, and all that remains of his work at the palace is the west wing. Nash also remodelled Brighton Pavilion for the Prince Regent.

Holy Trinity Church has a marvellous interior. The building has an iron frame (thanks to Henry Cort's achievements) with slender piers and flat arches of Tudor shape. Inside it is high with thin iron pillars, and was originally galleried all round. Now only the west gallery survives. Towards the chancel there is a memorial to Sir Charles Thompson who died commanding the channel fleet in 1799; it has figures of sailors, one with a sextant. (*Westbury Manor Museum*)

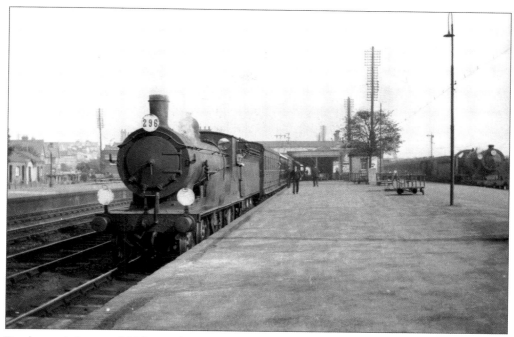

Fareham station, *c.* 1950. At the extreme west end of West Street is the railway station, built by Thomas Brassey, which opened in 1841. The stone part of the station is the original building. Sadly, as with so many stations these days, there is little to fire the imagination. The station had its own hotel, aptly called the Railway Hotel, which was at 251 West Street and traded from 1878 to 1959. Every Boxing Day the Fareham Hunt gathered outside this hotel. *(Westbury Manor Museum)*

Fareham station approach. *(Westbury Manor Museum)*

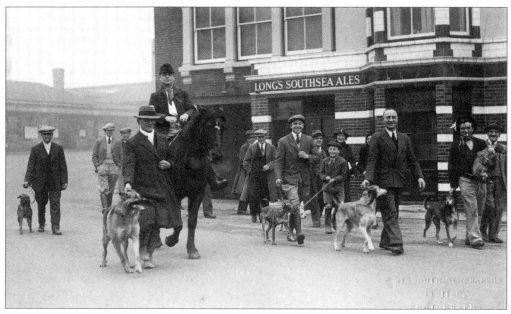

The Fareham Hunt outside the Railway Hotel. Mr Sandys is seen here on horseback.
(Westbury Manor Museum)

Fort Fareham, 1959. On the edge of the town is Fort Fareham, a Palmerstonian fort, wooded
around the outside with an industrial estate in the middle. Not far from here lies the
eighteenth-century hamlet of Catisfield where in the 1970s Roger Moore, famous for his role
as James Bond, was rumoured to live. *(Westbury Manor Museum)*

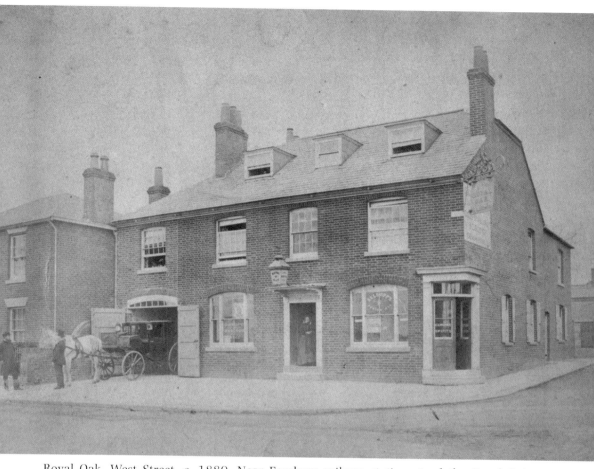

Royal Oak, West Street, *c*. 1880. Near Fareham railway station stood the Royal Oak, a welcoming public house. The pub still stands on the junction with West Street, Quay Street and Trinity Street. On the far right of this photograph is Hinxman's garage, which sold a variety of vehicles. It hadn't always been Hinxman's, though; it was previously Coles, coachbuilders and coachmakers to George IV. They were once charged 7s 6d for causing a traffic jam by displaying their coaches on the road. In 1923 Hinxman's was based at 36 and 38 West Street. By 1970 the garage had been taken over by Stringer's. *(Westbury Manor Museum)*

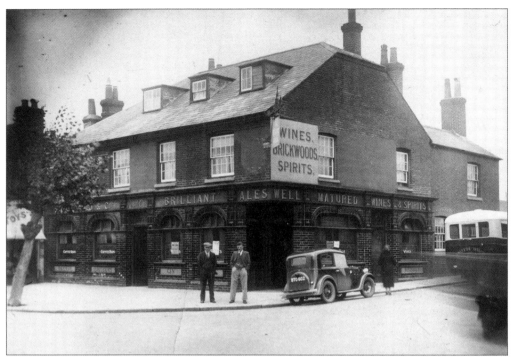

Royal Oak, West Street, 1935. *(Westbury Manor Museum)*

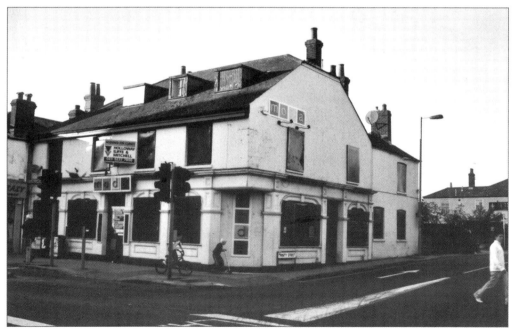

The Royal Oak suffered a recent name change to moda, which helped secure its fate. Today the premises are in a sad state of decay, but renovations are under way and hopefully it will be restored to its former glory. *(Tim Saunders)*

2

Portland Street

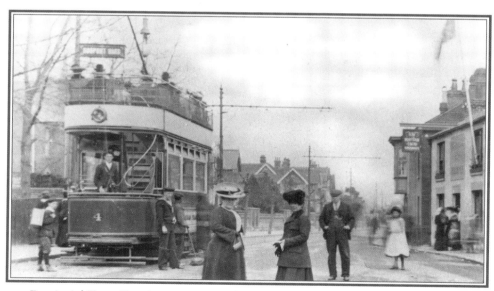

Provincial Tram Terminus, *c.* 1900. There were tramlines in Old Portland Street.
The trams provided cheap transport to and from Gosport.
(Westbury Manor Museum)

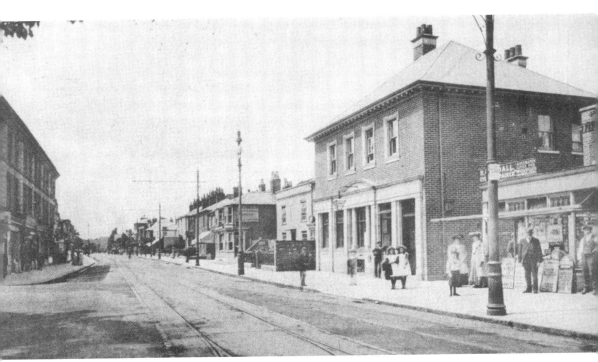

Portland Street, *c.* 1920. *(Westbury Manor Museum)*

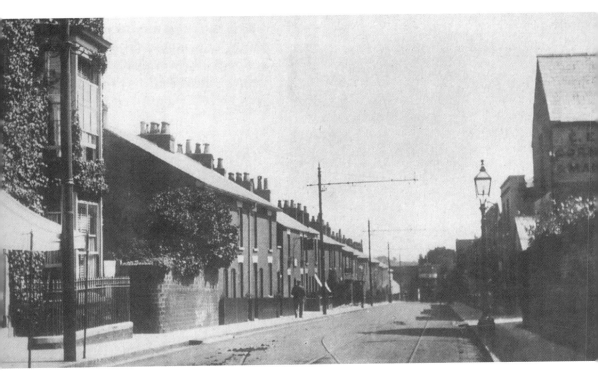

Portland Street, *c.* 1920. *(Westbury Manor Museum)*

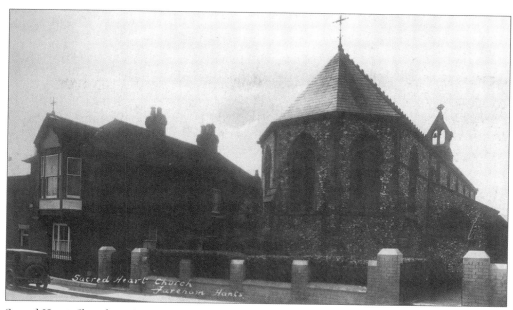

Sacred Heart Church, *c.* 1900. Unfortunately records of Catholicism in Fareham before 1939 were destroyed in Portsmouth during the Second World War. Queen Elizabeth I ejected Bishop White of Winchester in 1559 and the Catholics struggled for another 250 years, practising their religion at risk of their freedom and their lives. The parish churches were taken over by the Queen's official church and those who did not attend were fined and imprisoned if their absence continued. In these extremely tough times there were two Fareham men who despite the penal laws went to France to become priests. The first was Father Augustus Hill, who was ordained in 1660, the second Father John Route. Both priests were ordained in Douai near Calais but returned to England to continue their service to God. The penal laws failed to eliminate Catholicism from England. By 1791 mass had become legal and priests were free to practise Catholicism. In 1829 came the emancipation and by 1882 the Diocese of Portsmouth was created.

The Fareham Mission was first started in 1873. One of the first to devote himself to the Catholics of Fareham was Father James Bellord, a military chaplain serving troops in the neighbouring forts. Mass was said once a week in a shed, known as the Tabernacle, in an alley off West Street. It was small and temporary. In October 1874, Father Thomas Foran was appointed as chaplain to the Catholic troops stationed on Portsdown Hill. He took up residence at 11 High Street and also administered to the Catholics in Fareham. With the backing of Mr Stapleton-Bretherton and Mrs Grace, he obtained a piece of land between Hartlands Road and Portland Street, originally a timber yard. On 4 September 1878 the church, dedicated to the Sacred Heart, was opened by Dr James Danell, the Bishop of Southwark. The church was designed by John Crawley of Bloomsbury, London. Towards the end of 1887 Father Edward Collins came to Fareham from Fordingbridge. He worked in the parish for eighteen years. It was Father Collins who arranged for the School Room (the present church hall) to be built in 1894, with the generosity of the Stapleton-Bretherton family. The total cost was £134 1*s* 6*d* which included the erection, furniture and gas fittings. In 1905 Father Collins was forced to resign owing to ill-health and old age but not before the church had been registered as a place for the solemnisation of marriage in February 1903. The parish had a football team, tennis and dancing clubs, a drama society and a flourishing choir that was well known throughout Fareham. The church was nearly lost during the war. On Saturday 10 January 1941 an incendiary bomb fell through the roof and lodged in the organ gallery. Sailors attending a social in the church hall saved the church from absolute destruction. *(Westbury Manor Museum)*

Sacred Heart Church, 2007. *(Tim Saunders)*

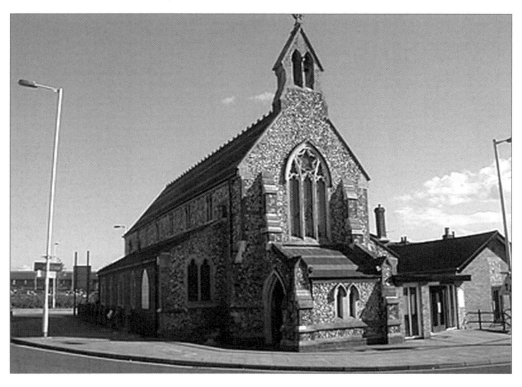

3

High Street

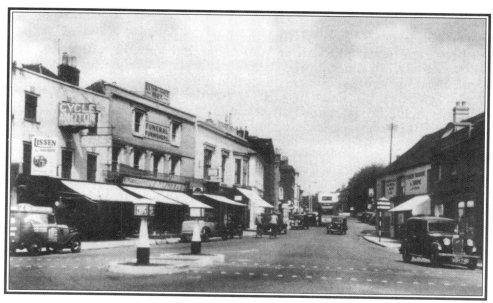

High Street, Fareham, *c.* 1930. *(Westbury Manor Museum)*

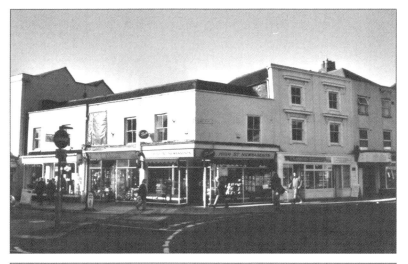

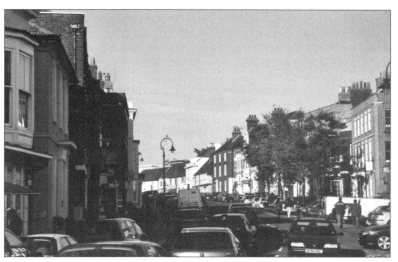

High Street, 2006. Unfortunately this end of High Street looks as if it has seen better days, but there's nothing a good lick of paint wouldn't improve. On the left of the first photograph, a window has been removed and replaced with a plastic covering – hopefully this is a temporary measure. The third photograph shows the best part of High Street in the distance. (*Tim Saunders*)

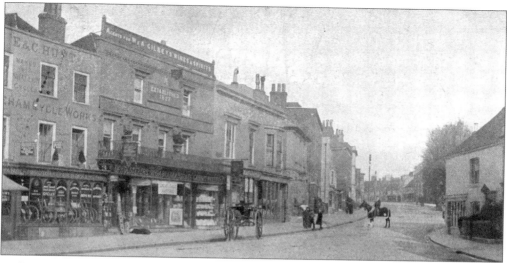

High Street, *c.* 1905. High Street has been described by the historian David Lloyd as 'one of the finest high streets in the south of England'. Having walked along West Street and round the corner into High Street, you really feel as if you have just stepped back in time (if you disregard all the parked cars and traffic of course). Let that imagination run wild and think of those smugglers in the eighteenth century mischievously going about their business as if part of a Robert Louis Stevenson novel. What is today probably the most respectable part of town was once alleged to have a nearby red light district. The High Street is a superb display of Georgian architecture. Until the nineteenth century this was the main street of the town. It was here that the Great Cheese Fair was held on the last two days of June. Slowly the commercial focus moved to West Street. (*Westbury Manor Museum*)

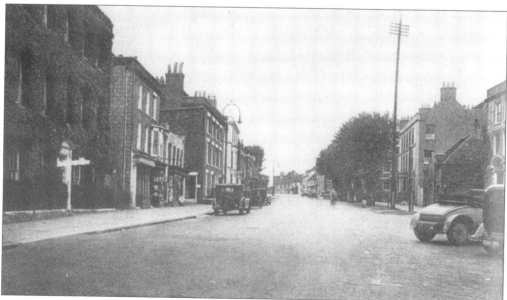

High Street, *c.* 1900 (*Westbury Manor Museum*)

The High Street, *c.* 1930. It is summertime and a mother walks up the street hand in hand with her young daughter. Meanwhile, a lady to the left stands in the road with her hands on her hips, as if in disgust at the hell-raising motorcyclists roaring by. Some things never change . . . *(Westbury Manor Museum)*

No. 12 High Street was where the mother of Arthur Lee lived. Born in 1868, Arthur Lee was the MP for South Hampshire; he later became Lord Lee of Fareham. He restored Chequers, and presented it, together with its 1,500-acre estate and many works of art, to the nation for the use of the prime minister. Chequers Court, a country house near Ellesborough, to the south east of Aylesbury in Buckinghamshire, lies at the foot of the Chiltern Hills. Towards the end of the nineteenth century, the house passed through marriage to the Astley family. They let the house to the Clutterbuck family, who loved it so much that when they left in 1909 they had a replica built in Bedfordshire. Following the Clutterbucks' departure, the house was taken on a long lease by Mr and Mrs Arthur Lee. Arthur and his American heiress wife Ruth were in need of a country home and Chequers suited their needs. They immediately commenced restoring the grand old property. In 1912, following the death of the last ancestral owner, Henry Delavel Astley, Ruth Lee and her sister purchased the property and later gave it to Arthur. Could this have been for tax purposes or just a kind gesture? During the First World War the house became a hospital and then a convalescent home for officers. The property houses one of the largest collections in the UK of art and memorabilia collected by Oliver Cromwell. After the war the childless Lees realised that previous prime ministers had belonged to the landed classes but the new leaders did not have the country palaces to entertain foreign heads of state, or tranquil places to relax. After lengthy discussions with then prime minister David Lloyd George, Chequers was given to the nation as a country retreat for the serving prime minister by the Chequers Estate Act 1917. Arthur and Ruth Lee, by this time Lord and Lady Lee of Fareham, left Chequers on 8 January 1921 after a final dinner at the house. A stained glass window commissioned by Lord and Lady Lee in the long gallery of the house bears the inscription: 'This house of peace and ancient memories was given to England as a thank-offering for her deliverance in the great war of 1914–1918 as a place of rest and recreation for her Prime Ministers for ever.'

High Street, 2006. Until about 1850 the High Street and Union Street were together named North Street. Just to make matters even more confusing it was not until the 1870s that the houses in the High Street were allocated numbers – probably at the insistence of a confused Post Office. The earliest buildings in the High Street were originally timber-framed structures no doubt because iron was not strong enough to use in building until Henry Cort came along. *(Tim Saunders)*

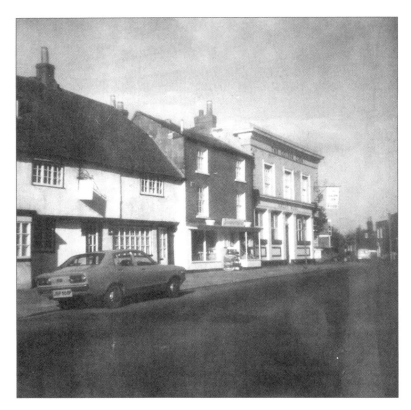

The Golden Lion, High Street, *c.* 1970. The P-registered Datsun parked by the side of the road is quite a new car. There aren't many of those around now . . . (*Westbury Manor Museum*)

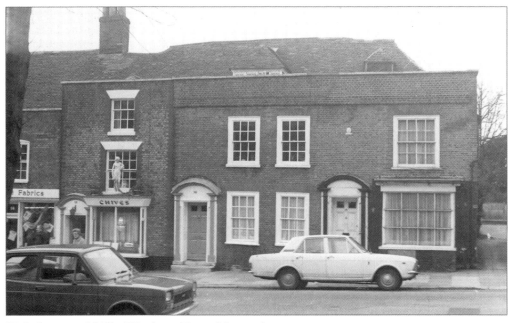

High Street, *c.* 1970. (*Westbury Manor Museum*)

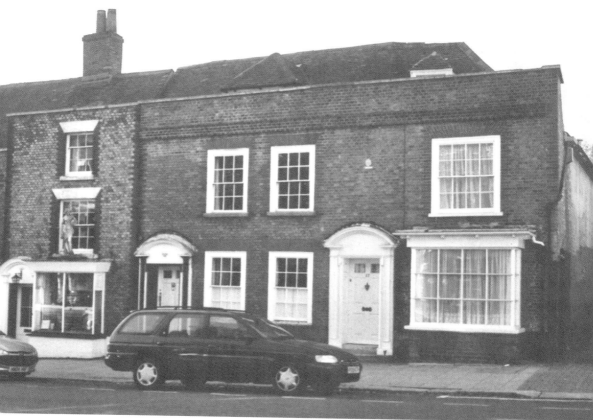

Chives, 15 High Street, 2006. Not much has changed here apart from the odd colour of the doors, and of course the cars are newer. Pleasingly the statue still stands above the Chives shop window. Today Chives has a fascinating plaque in its window detailing the history of this building. It informs us that behind the façade is a very early timber-framed building of national importance. Its roof has a structure which has so far only been found in a few English roofs, although it is of a type common in France, thereby throwing light on the relationship between French and English carpentry at an early date. The house is of national importance because it is the most complete timber-framed building with an ancient roof structure like this in the country. There is a similar but less complete house in Winchester that dates back to 1292. (*Tim Saunders*)

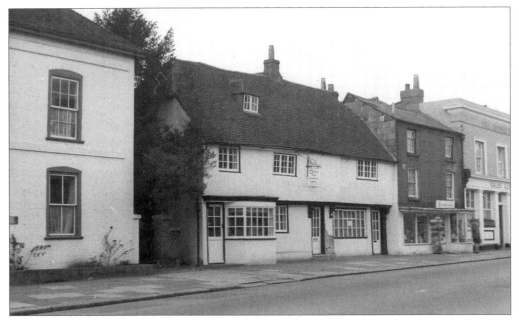

High Street, *c.* 1970. *(Westbury Manor Museum)*

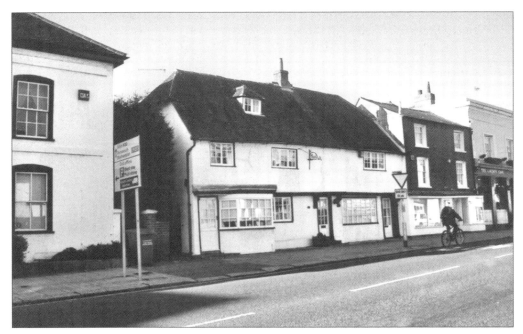

High Street, 2006. Again, as one would expect there is little change in this well-preserved part of Fareham. It is noticeable, though, that a signpost has crept its way into the High Street: it is just outside the nearest house in the photograph. There is another signpost outside the furthest away door on the second property. It seems that a chimney stack has been lost on the second property but the original wood-framed windows are still fitted. A cyclist makes his way along High Street. Is he heading for Wickham? *(Tim Saunders)*

High Street, *c.* 1970. An interesting selection of motor cars graces the street in the 1970s. The small building in between the two three-storey properties is boarded up and the nearest three-storey building is missing its chimneys. Its lead porch remains unpainted and there is a 'for sale or to let' sign at the front of the building. The agent, L.S. Vail & Son, established in 1929, merged with Pearson Williams, established in 1976, to become Vail Williams, a property consultancy, in 1988. The firm now has over 140 staff across a network of nine offices in locations that include Basingstoke, Southampton, Portsmouth and as far afield as Birmingham and London. The building to its right still seems to be a private residence. *(Westbury Manor Museum)*

The small building has become a welcoming, quaint little restaurant. High Street, 2006. *(Tim Saunders)*

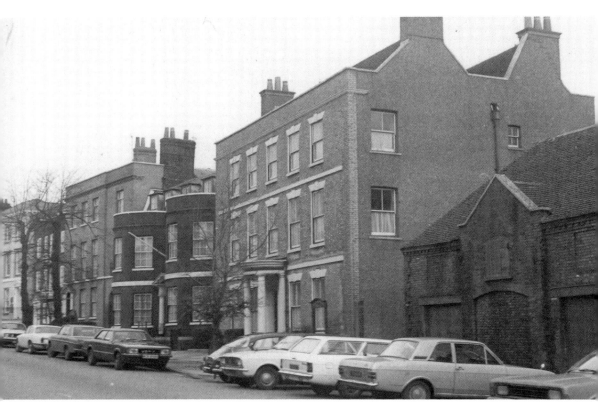

High Street, *c.* 1970. The smaller building to the right is now a restaurant. Nos 23, 24 and 25 High Street were originally timber framed. Nos 26 and 27 have undergone several conversions, including the front elevation. It is likely that all the five houses (nos 23 to 27), were built for merchants because each house has a shop front. In nos 26 and 27 there are cellars, reached by trap doors, probably once used for the storage of merchandise. The walls and ceilings of these properties are of lathe and plaster. *(Westbury Manor Museum)*

High Street, 2003. *(Tim Saunders)*

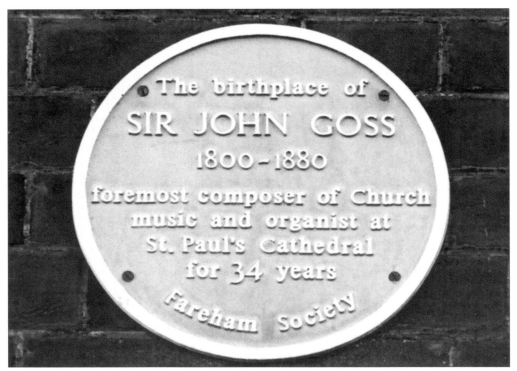

The plaque commemorating Sir John Goss at 21 High Street, 2006. Sir John Goss, the composer of English cathedral music and hymns, was born at 21 High Street on 27 December 1800. He was a chorister at the Chapel Royal at St James's Palace. Goss died in 1880. *(Tim Saunders)*

Charlotte Yonge, who lived from 1823 to 1901 and lived in Otterbourne near Winchester, often visited the High Street. Her book *A Reputed Changeling* is set in Fareham. Yonge was a best-selling author in her time; her output was prodigious – over 250 works. Most were reprinted many times, and many were published all over the world both in English and in translation.

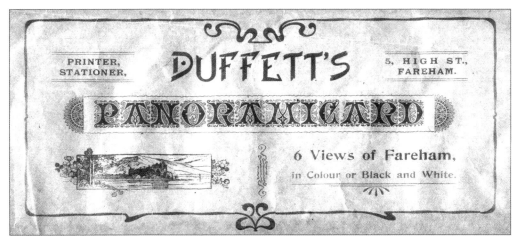

Duffetts packaging. Duffetts was also based at 5 High Street. *(Westbury Manor Museum)*

Nos 26 to 27 High Street, 2006. Next door to the Golden Lion, at 26 High Street, lives Beryl Whitehurst who came to Fareham in 1969. It is fascinating to see the change of uses one particular building can undergo. From 1898 to 1899 Beryl's home belonged to G. Consens, a saddler. This became Miss J. Fry's hairdressers from 1940 to 1941 and from 1953 to 1954 it was I. Houghton, fruiterer and florist. 'When we arrived, the building was in a terrible state. It had belonged to an old couple before we bought it and had been a grocery shop.' So what brought Mrs. Whitehurst and her husband to Fareham? 'I originally came from Burton-upon-Trent. My husband had been in an air crash in the RAF and he had been in business with his sister who had died. My uncle lived at Emsworth and we were fond of Fareham, with the sea nearby – my husband particularly because he was a keen fisherman.' Beryl is an interior designer specialising in making handmade lampshades so she had the expertise to improve the property. 'We had the house adapted and slightly

converted. A stairlift was fitted too. We discovered a wall painting behind the plaster dating from 10 June 1604. There aren't many houses where you would find that. Not surprisingly, the house is in a conservation area, meaning that it's difficult to make huge alterations and you're not allowed to fit double glazing.' After only living there for a year Beryl opened her interiors shop in 1970, and enjoyed twenty-five years of trading before finally closing in 1995 when her husband died. 'The shop was downstairs and we lived upstairs. I've thoroughly enjoyed living here. It suited us well.' Beryl worked on the Cunard ships, designing their penthouse suites, and *Ryad*, a Saudi Arabian yacht. From 1974 Beryl made lampshades for the queen. 'I made the shades for the Royal Yacht Britannia as well as doing the interior design on the yacht. I never actually met the queen though. I took fabrics onboard or to the palace for her to see. Peter Ford, my business partner, worked on the Royal Yacht and it was through him that I was able to board the yacht. The yacht became like a lovely old country house at sea, which travelled over one million miles in its forty-four years' service.'

The High Street has had its fair share of businesses. At no. 3a between 1935 and 1959 was H.H. & R.J. Saunders, wine merchants, which was part of the Saunders brewery in Wallington. Between 1878 and 1899 H. Gilbert, bookseller and printer was based at 5 High Street. In 1878, at no. 54 was John Dean, wheelwright. *(Tim Saunders)*

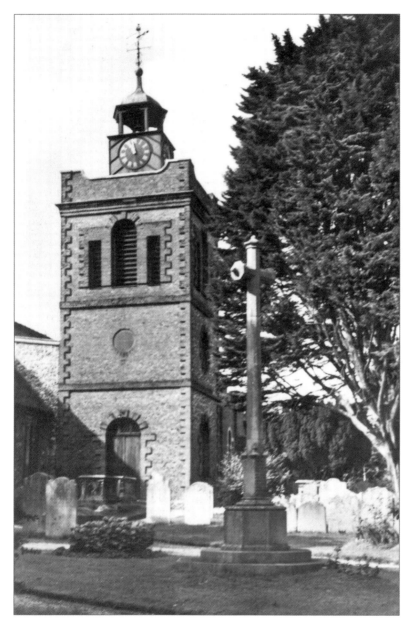

The church of St
Peter & St. Paul,
c. 1930.
*(Westbury Manor
Museum)*

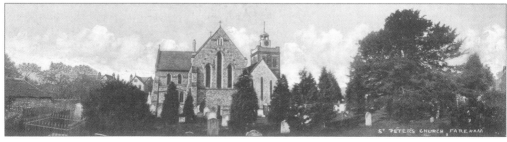

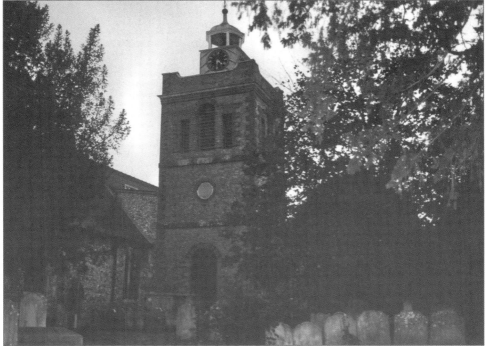

The church of St Peter and St Paul is at the top of the High Street and is hidden by yews. The path is partly made from grey ceramic paving stones produced by the Funtley brickworks. The church is built of brick and flint and the heavy brick tower was built in 1742. It is capped by an elegant wooden cupola. The only medieval part to survive is the original chancel. The rest of the church, apart from the tower, was rebuilt in 1930. There are memorials to naval officers, including one to the captain of the ship *Hero* which was wrecked in 1811: the crew of 600 drowned. Near the church is a row of three Victorian flint cottages. Looming over them is a modern eyesore of a building, Fareham's largest – home of Fareham Borough Council.

Ferneham Hall, 2006. *(Ferneham Hall)*
Right: Tony Hadley, the lead singer of Spandau Ballet,
performing at Ferneham Hall, 2005. Spandau Ballet were
famous for such hits as 'Gold' and 'True'. Ferneham Hall
opened in 1982 and in its 24 years has had many stars of
stage and screen perform there. *(Tony Hadley)*

4

East Street

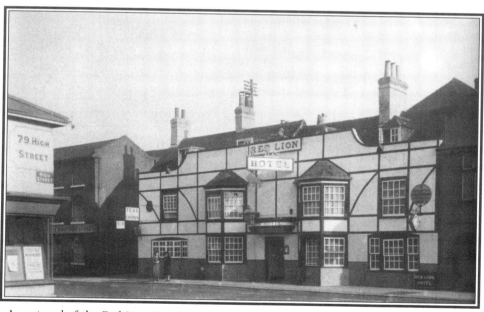

A postcard of the Red Lion Hotel, early twentieth century. Fairs were held in East Street until 1871. This wide street is lined with trees and the first of the 1897 Jubilee electric lamp standards can be found at wide intervals along the street. These are some of the earliest electric lamps to survive and have large swan necks. From East Street, Bath Lane leads to the shore. The baths were built at the sea end of the road in 1838 and were filled with sea water. (*Westbury Manor Museum*)

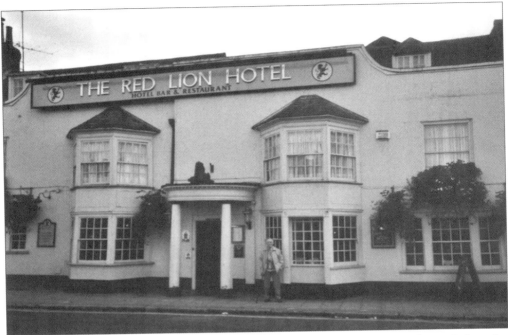

The Red Lion, 2006. There is not a great deal of change. A chimney-stack is missing, the mock wood has been removed from the front and the signage has changed. The present owners have trailed some plants around the front. There is a more substantial porch over the front door now, with balustrades to support it. The Red Lion stands elegantly beside Georgian buildings in East Street. It is a famous coaching inn where the town's law courts were held for many years. Re-fronted in about 1810 with a shallow semi-circular porch, it also had a courtesy coach that took passengers to the station. When the motor car first arrived in Fareham the Red Lion sold petrol. At one time it was known as the Red Lion Hotel but today is simply a pub. *(Tim Saunders)*

Sir William Cremer, *c.* 1860.
The trade unionist and Nobel
prize winner Sir William
Randal Cremer MP was born
in 1821 in Fareham. He is
credited with setting up the
International Court in The
Hague. His father, a coach
painter, deserted the family
when Cremer was still a
young boy. At 15 Cremer was
apprenticed to an uncle in the
building trade and eventually
he became a carpenter. Aged
24, Cremer went to London.
Six years later he was helping
organise the campaign for a
nine-hour day, and he went
on to become a national
leader of the Carpenters'
Union and a member of the
London Trades Council. In
1864 the International
Working Men's Association
was established and Cremer
was elected general secretary.
In 1874 he tried to win a seat
in parliament, but failed.
Eventually he won an
election, and at the age of 57
he entered parliament as a
liberal. A committee of

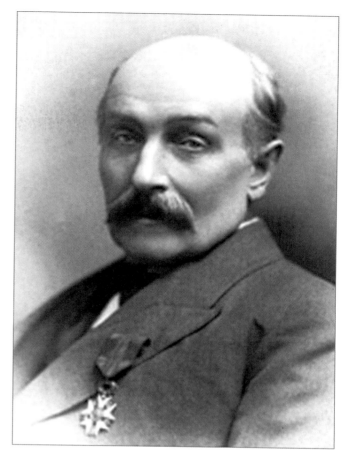

working men which he formed in 1870 to promote England's neutrality during the Franco-
Prussian conflict became the Workmen's Peace Association in 1871, and this provided the
keystone for the International Arbitration League, an association to which he contributed his
time and money. Cremer was awarded the 1903 Nobel Peace Prize (value £8,000) for his
efforts in the cause of international arbitration, which he gave in trust to the International
Arbitration League. He was knighted in 1907. Stricken by pneumonia, he died in 1908.
Cremer left money to build the Cremer almshouses which were near Fareham's railway
station. Sadly these were demolished when the road was widened. *(Westbury Manor Museum)*

Fareham Quay, *c.* 1930 *(Westbury Manor Museum)*

An advertisement for Percy See boatbuilders, *c.* 1930. Between 1927 and 1939 Percy See built hydroplanes and cruisers powered by outboard motor at Lower Quay, Fareham. See's Speedboats built the boat named *Snotty* in which the Hon. Mrs Victor Bruce broke the cross channel record. *(Westbury Manor Museum)*

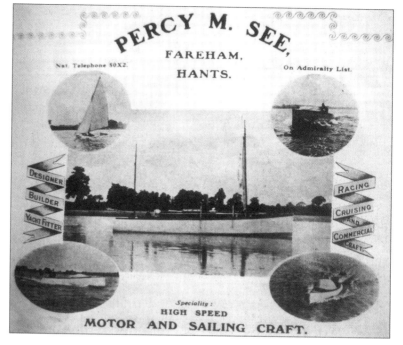

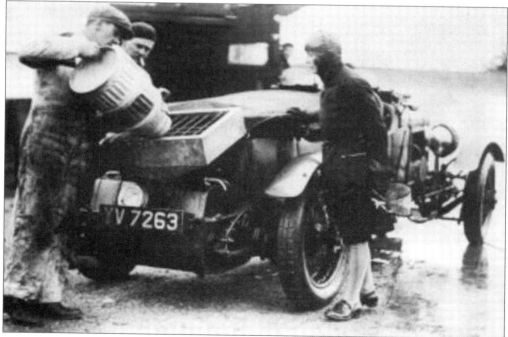

The Hon. Mrs Victor Bruce stands on the right, watching re-fuelling through the Le Mans-style quick fill funnel during her record attempt at Montlhéry in June 1929. Driving Birkin's 4½ litre single handed through appalling weather conditions for 24 hours, she took the Class C record at 89.57mph, and the 2,000 miles and 3,000 km records at the same speed. *(Westbury Manor Museum)*

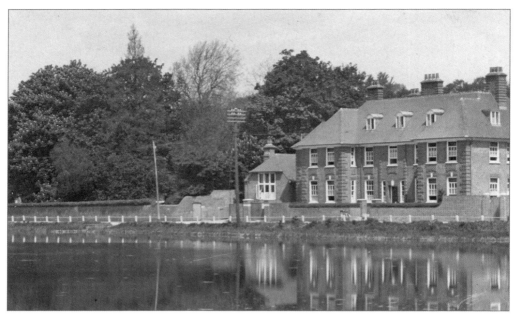

Home for waifs and strays, *c.* 1910. *(Westbury Manor Museum)*

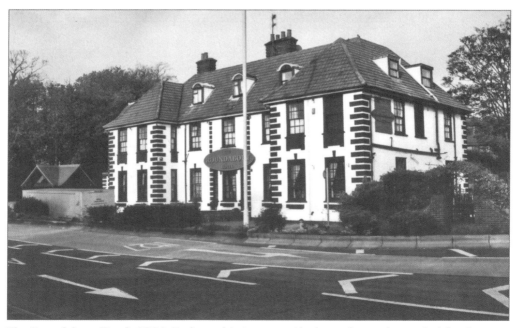

The Roundabout Hotel, 2006. Perhaps this is not an ideal spot for a relaxing holiday because a busy roundabout (as the name suggests) is right on its front door. Originally this was an industrial home for girls aged 14 to 16 years, established in 1869 by Lady Larcon. It was transferred to the Church of England Society for Homes for Waifs and Strays in 1884. In 1907 it was rebuilt as St Edith's. There were usually twenty girls here, who trained to be servants for housework, laundry and cooking. *(Tim Saunders)*

5

Cams Hall

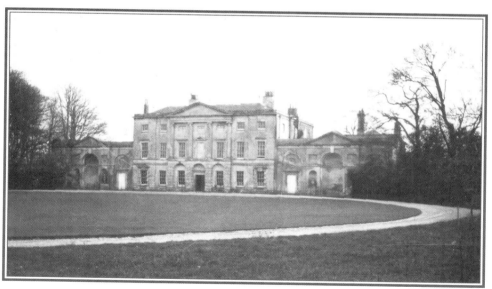

The opulent Cams Hall, 1936. (*Westbury Manor Museum*)

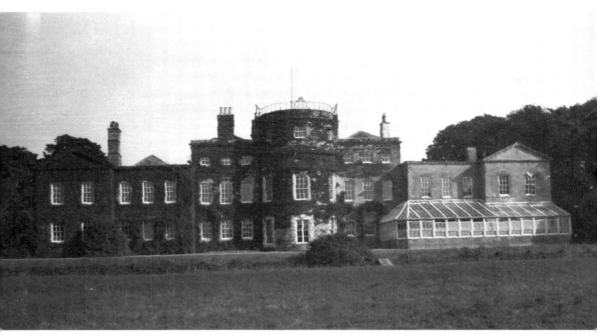

Cams Hall, 1936. Cams Hall lies just off the A27. It was the splendidly elegant property of General John Carnac, a senior official of the East India Company. Carnac had engaged the architect Jacob LeRoux to design for him a spacious mansion with a classically pedimented façade and grand south-facing rooms with views over Fareham Creek. To the north the house looked out towards the great sweep of Portsdown Hill and Wallington. In 1781 Peter Delmé purchased it, probably to make his wife, Lady Betty's life easier so that she could travel to and from Hampton Court with ease. (She was a lady-in-waiting to Queen Charlotte, wife of George III.) Little could they imagine that 15 acres of their estate would be lost to the A27 in years to come. They moved across Fareham from Place House (now Titchfield Abbey) to occupy the mansion and then spent a small fortune on partly rebuilding and enlarging the house. This superb mansion remained in the hands of the Delmés for over 100 years. The Delmé family were Walloons of Belgian and French extraction, who first went to Norfolk from the northern province of Lorraine to escape religious persecution.

John Delmé was seventeen when his father died; two years later, while still under age, he married Frances Garnier of Rookesbury Park. He had seven sons and four daughters before dying aged just 36. One of his sons, Henry Peter Delmé of Cams Hall, was High Sheriff of Hampshire in 1925.

Sadly the Delmé family died out and the last male heir decided to sell. Montague Foster bought the estate and rented it out. It was sold again in 1895 and then had several owners, even being used by the Admiralty during the Second World War. During the 1950s a caravan park was started and the land was farmed by the Hill family for a number of years. During this period the buildings fell into disrepair and the house became dilapidated. It was sold to Jonathan May who intended to build a housing estate. After the war May's building work was destroyed by the Bedenham explosion, a lack of money and planning permission.

In 1954 Hampshire County Council bought part of the estate to develop the Fareham Grammar School for Girls. Fareham Girls' Grammar School was established in 1956 and officially opened in 1957. (*Westbury Manor Museum*)

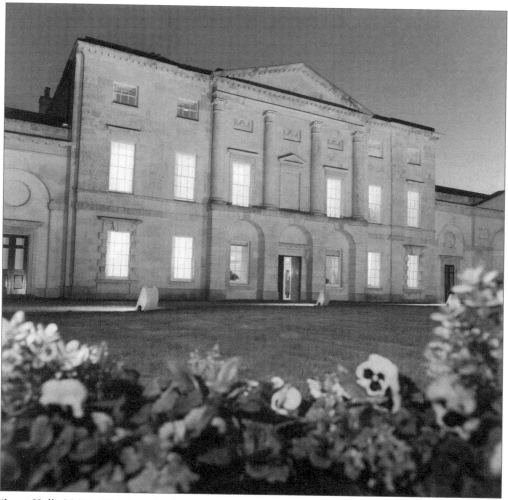

Cams Hall, 2006. (*Tim Saunders*)

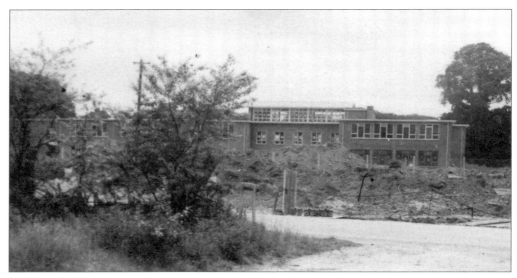

Fareham Girls Grammar School being built, 1956. *(Westbury Manor Museum)*

Fareham Girls Grammar School, *c*. 1956. *(Westbury Manor Museum)*

Fareham Girls Grammar, *c.* 1956. (*Westbury Manor Museum*)

Fareham Girls Grammar, *c.* 1956. (*Westbury Manor Museum*)

Fareham Girls Grammar, *c.* 1956. *(Westbury Manor Museum)*

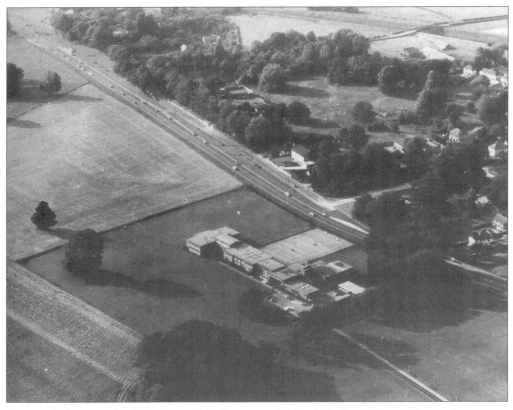

An aerial photograph of Fareham Girls Grammar, 1963. *(Westbury Manor Museum)*

The gardens at
Cams Hall, 1936
(*Westbury Manor
Museum*)

The old buildings became derelict. Mr Church stepped in, but was killed when his plane crashed, and work was taken over by Strand Harbour Securities.

Today the Cams Estate comprises an extremely successful business park set in the stunning surroundings of the Cams Hall Estate Golf Club with its twenty-seven manicured greens. Peter Alliss and Clive Clark designed the parkland course. The centrepiece of the business park is the renovated Cams mansion and adjoining Home Farm buildings complex, both of which have been converted to office use. New office buildings have been completed alongside at Delmé Place and Carnac Court.

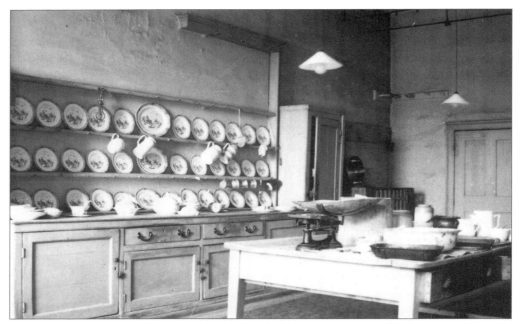

The kitchen at Cams Hall, 1936. The kitchen had an enormous Welsh dresser and sturdy kitchen table. Here the cook has loaded up the scales with flour, perhaps to make a fresh loaf of bread or a scrumptious cake. *(Westbury Manor Museum)*

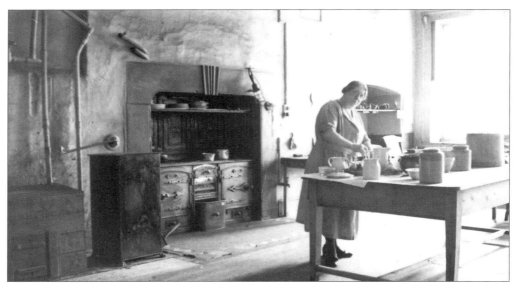

The cook at Cams Hall, 1936. Aware of hygiene, she has her hair tied back. It seems that she is preparing afternoon tea. The large windows in the kitchen would have afforded lovely views of the gardens and also let much light in. One hopes that this cook was happy and satisfied in her work but sadly, as is the case with many old photographs, she does not smile. Usually such staff lived on the premises. *(Westbury Manor Museum)*

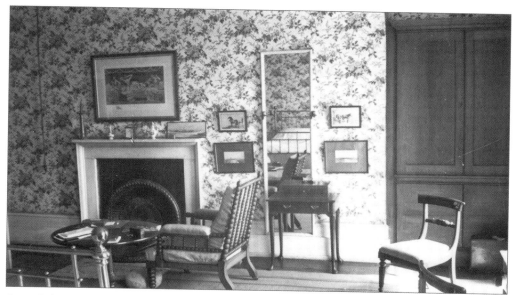

One of the rooms at Cams Hall, 1936. This room has high skirting boards. Could that be William Morris wallpaper? *(Westbury Manor Museum)*

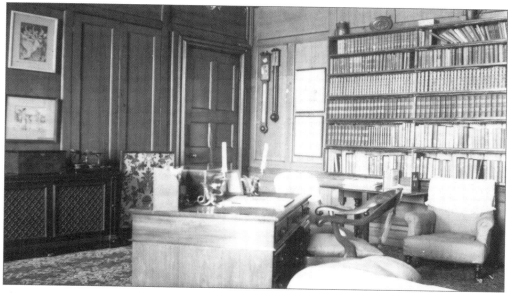

The master's library at Cams Hall, 1936. The panelled room together with its gigantic bookcase made for a wonderful place to enjoy a good read. Candles on the desk suggest that electricity was not fully installed and that the owner worked late into the night. Needs must to keep such a lavish property. *(Westbury Manor Museum)*

Cams Hall, 1936. Cams Estate has a superb setting, with outstanding views to Portsmouth Harbour, and the approach is by an impressively long drive which in those days passed through extensive and immaculate grounds. *(Westbury Manor Museum)*

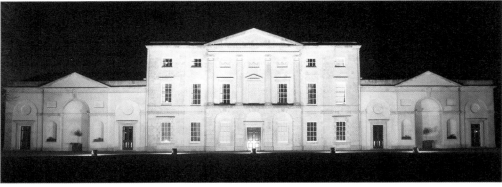

Cams Hall at night, 2006. *(Cams Hall)*

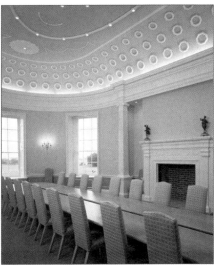

The meeting room at Cams Hall, 2006. Perhaps the markings on the ceiling offer necessary entertainment during a dull board meeting. *(Cams Hall)*

6

The Outskirts

A rough sketch of St Mary's Church. St Mary's Church is not mentioned in the Domesday Book. The first known reference to its existence is dated 1122. Today's building is a fine example of Victorian Gothic and it is listed by English Heritage as a building of special architectural or historic interest. There was probably a Saxon church at Alverstoke and this was succeeded by a Norman church entirely rebuilt in 1625. The church was built in three stages. The present tower was built in the early twentieth century to commemorate the end of the South African War. It has eight bells weighing up to 681kg, dedicated to the memory of those who fought and fell in the First World War. *(Westbury Manor Museum)*

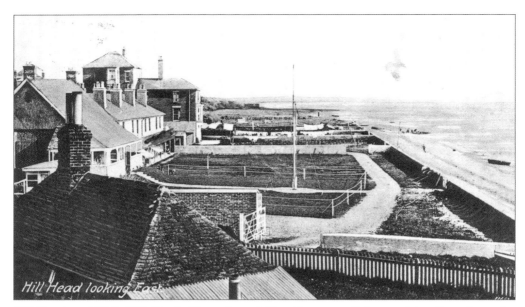

Hill Head, *c.* 1913. Hill Head, Warsash and Hamble were all favoured landing places for contraband goods. *(Westbury Manor Museum)*

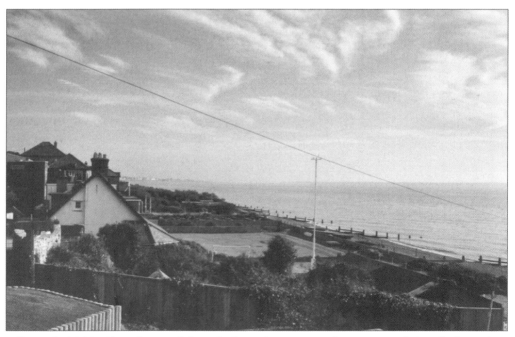

Hill Head, 2006. The advent of the telephone has meant that an unsightly telephone line impinges on the view but pleasingly a flag pole still stands. Houses that once had cast-iron downpipes now have plastic ones. Well-built wooden sash windows have given way to inferior plastic double glazing. One thing however, remains unchanged: Hill Head is a beautiful spot where the sea can be thoroughly enjoyed.. *(Tim Saunders)*

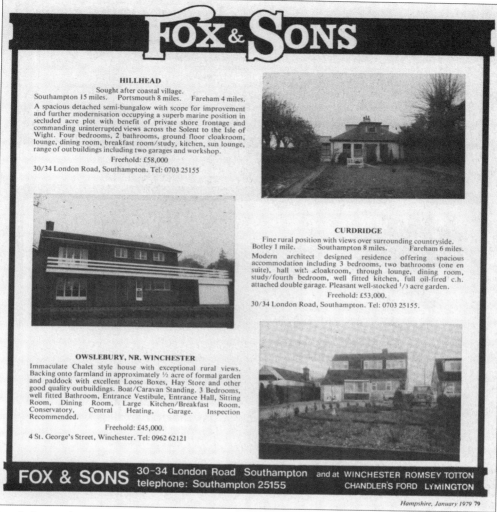

FOX & SONS

HILLHEAD
Sought after coastal village.
Southampton 15 miles. Portsmouth 8 miles. Fareham 4 miles.

A spacious detached semi-bungalow with scope for improvement and further modernisation occupying a superb marine position in secluded acre plot with benefit of private shore frontage and commanding uninterrupted views across the Solent to the Isle of Wight. Four bedrooms, 2 bathrooms, ground floor cloakroom, lounge, dining room, breakfast room/study, kitchen, sun lounge, range of outbuildings including two garages and workshop.

Freehold: £58,000

30/34 London Road, Southampton. Tel: 0703 25155

CURDRIDGE
Fine rural position with views over surrounding countryside.
Botley 1 mile. Southampton 8 miles. Fareham 6 miles.

Modern architect designed residence offering spacious accommodation including 3 bedrooms, two bathrooms (one en suite), hall with cloakroom, through lounge, dining room, study/fourth bedroom, well fitted kitchen, full oil-fired c.h. attached double garage. Pleasant well-stocked 1/3 acre garden.

Freehold: £53,000.

30/34 London Road, Southampton. Tel: 0703 25155.

OWSLEBURY, NR. WINCHESTER
Immaculate Chalet style house with exceptional rural views. Backing onto farmland in approximately ½ acre of formal garden and paddock with excellent Loose Boxes, Hay Store and other good quality outbuildings. Boat/Caravan Standing. 3 Bedrooms, well fitted Bathroom, Entrance Vestibule, Entrance Hall, Sitting Room, Dining Room, Large Kitchen/Breakfast Room, Conservatory, Central Heating, Garage. Inspection Recommended.

Freehold: £45,000.

4 St. George's Street, Winchester. Tel: 0962 62121

FOX & SONS 30-34 London Road Southampton and at WINCHESTER ROMSEY TOTTON
telephone: Southampton 25155 CHANDLER'S FORD LYMINGTON

Hampshire, January 1979 79

Fox & Sons advertisement in the January 1979 issue of *Hampshire the county magazine.* This advertisement is for a property in Hill Head for just £58,000. Today, if this property still stands of course, it would be more likely to fetch at least £350,000. *(Paul Cave Publications Ltd)*

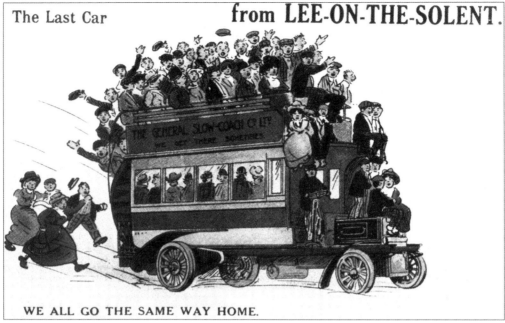

Postcards from Lee-on-the-Solent, 1920s. The public transport that served Lee gave cartoonists much enjoyment. The Lee-on-the-Solent Light Railway ran for forty years and comic postcards depicted the inefficiency of this service. One such card is called 'From Lee-on-the-Solent to Fort Brockhurst, and back in one day (Perhaps)'. It also shows a couple with the lady asking 'Shall we walk, darling?' To which the gentleman replies, 'No, we are not in a hurry, let us ride on the train!' *(Westbury Manor Museum)*

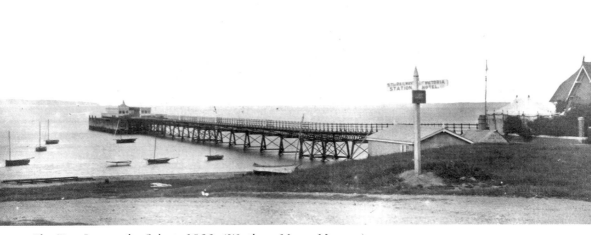

The Pier, Lee-on-the-Solent, 1923. *(Westbury Manor Museum)*

Lee-on-the-Solent lies just to the east of Hill Head. Pick the right day in August and you will be able to perch on the water's edge and enjoy the views of bustling Cowes Week – over the water at the Isle of Wight. Once upon a time Lee-on-the-Solent was a Fareham borough, but today it is part of Gosport. The term 'on-the-Solent' first appeared on our maps in 1894. Before that it was simply Lee. It is correctly named Lee-on-the-Solent without a capital T for 'the', although The Solent carries one. Lee-on-the-Solent is about 3 miles from Titchfield. 'I grew up there and learned to swim in the pool,' reminisced Mrs Hebbard of Gaylords Antiques in Titchfield. Unfortunately the swimming pool is no longer there, although the sea is extremely welcoming on a blistering hot August day. Until the early 1960s the town also had a lovely art deco tower, a ballroom and a cinema; the ballroom was reputedly one of the best in the south-east.

Today, Lee has its well-cared-for beach and a variety of shops that date from the 1920s and 1930s. It is still the base for the Marine Coast Guard Agency and the rescue helicopter for the area. It is also home to the Hovercraft Museum. Kite-fliers are attracted to Lee because of the wide open space. It is a good place to go gliding and it still has a fine sailing club. Until the 1930s there was a pier with a railway but this was destroyed by fire. Windsurfers and more recently jet-skiers have descended upon the town. Lee-on-the-Solent used to be known as Lee Britain – from the Le Breton family who featured in its early history. The land passed through many hands until in 1357 William Markes held it. On his death it passed to the abbot and convent of Titchfield and it came into the hands of Thomas Wriothesley at the Dissolution. Before the latter part of the nineteenth century Lee was very much a sleepy little fishing village. From 1884 Mr C.E. Newton-Robinson, his brother E.A. Newton-Robinson and their father Sir J.C. Robinson who lived in Swanage, Dorset, set about developing Lee (over the next twenty-five years) into a resort that would rival Bournemouth and Brighton. The highlight of its layout was to be the Marine Parade, stretching more than a mile in length with a width of 50ft. It became a magnificent promenade with wonderful views of the sea and the Isle of Wight.

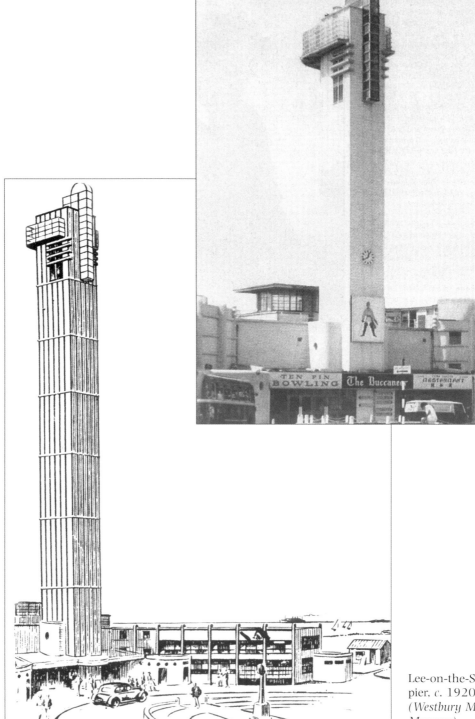

Lee-on-the-Solent
pier, *c*. 1920.
(*Westbury Manor
Museum*)

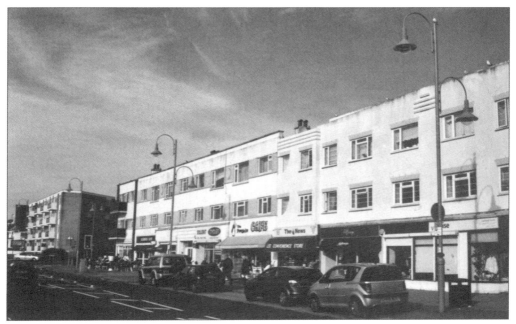

Lee-on-the-Solent, 2006. These photographs show that there is still a hint of art deco architecture to be found in Lee-on-the-Solent even though the town has lost its fine tower and pier. There is attention to detail in the design of the flats that is not often found today. The curved window surrounds and the fender effect above some of them add a certain style.

Repainted, the weather-beaten flats at Lee could look even more appealing. It is a pity that the shops underneath do not look better cared for. There is no denying it, Lee-on-the-Solent continues to be an enjoyable day out for the family, summer or winter.

Sir John Robinson wanted to build a pier and work began in 1885. At a length of 750ft the pier was not as large as those at Blackpool, Brighton or Southend but it was longer than those at Boscombe, Great Yarmouth, Southsea and Swanage. Messrs Galbraith & Church were the engineers for the project. There was huge rivalry between seaside resorts and Robinson wanted the best. In April 1888 Lady Robinson officially opened the pier. Noel Coward is reputed to have made his theatrical debut there in 1911, during a holiday at Hill Head. *Venus*, a new steamship run by the New Launch Company from Portsmouth, ran from May to the end of September, making eight trips every day between Lee and Clarence Pier at Southsea. The ride took forty-five minutes with a return fare costing 1s. There were also steamers that transported trippers over to the Isle of Wight from the end of the pier. From 1923, the Lloyd's Motor Packet Service ran between Lee, Cowes and Southampton. The pier became the hub of the community. *(Tim Saunders)*

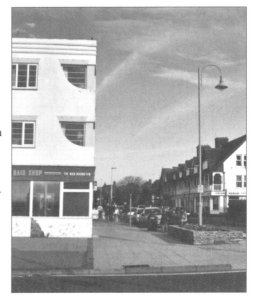

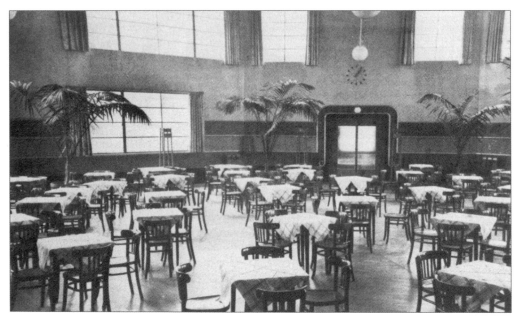

The café at the pier, c. 1930. At the start of the Second World War the War Department considered piers to be good landing points for enemy troops so they blew them up. This was the fate of Lee pier along with Bournemouth, Southend and Ventnor. This system, known as 'breaching', meant replacing the piers after the war at considerable expense. Consequently Lee pier was never rebuilt and Lee lost one of its greatest assets. (*Westbury Manor Museum*)

In 1935 Lee Tower was built. It dominated the coastline of Lee-on-the-Solent for thirty-five years. The prestigious design was by Messrs Yates, Cook & Darbyshire, and it was built by an appropriately named gentleman, Arthur Prestige. The structure comprised bars, a cinema, a dance hall, a restaurant and a roof terrace. Visitors could go up the 120ft high tower by luxury lift to enjoy sea views of the Solent – in much the same way as the Spinnaker Tower in Portsmouth operates today. Lee Tower opened on 26 December 1935 and in 1937 the tower company went into liquidation. Parts of it were leased out to different companies; for instance the Filer Brothers (who ran cinemas along the south coast) took over the cinema. The tower was occupied by American allies during the Second World War. Films ceased to be shown in 1958. The hall was used for all-in wrestling in 1961 and also ten-pin bowling. Gosport Borough Council inherited the complex and in the late 1960s it was demolished.

This seaside town has a special relationship with the hovercraft, which was propelled into being by Sir Christopher Cockerell, a Norfolk boat-builder and electronics engineer. Although earlier ideas had been mooted, it was Cockerell's experiments and demonstrations that led to the SRN1 becoming the world's first hovercraft. It was built by Saunders-Rowe on the Isle of Wight and had a test run from Lee-on-the-Solent to Cowes in 1959. Did you know that today you can build a fully operational hovercraft for as little as £250? The Hovercraft Museum at Lee will be happy to tell you how.

Another notable Lee resident was Sir Thomas Lipton, of greengrocer and tea fame. He was a keen sailor and tried to enter the America's Cup no fewer than five times. Sir Thomas applied to join the Royal Yacht Squadron and was refused because he was in trade. Outraged, he built Ross House opposite Cowes from where he could thumb his nose at the committee every day. Ironically Lipton's house was taken over by the captain of the Royal Yacht Squadron in the 1930s. Flats have now been built there.

Park Gate, 1934. The motor car was still a rarity at this time. Rarely will you see an advertisement for a business scrawled on the roof of a building today. Park Gate Garages sold oil for motor cars as well as bicycles. *(Westbury Manor Museum)*

Park Gate, 2006. Gone are the days of sedately walking across the road as the gentleman in the old photograph is doing. Today it is more a rush for your life as motorists hurtle through this once-pleasant village. In spite of numerous accidents there are still no speed cameras or any speed enforcement. In addition there continues to be no zebra or pelican crossings along the busy Botley Road. *(Tim Saunders)*

Portchester is surrounded on three sides by the sea. The old village lies close to the castle walls; most of Castle Street is a conservation area, and contains an interesting variety of buildings, predominantly eighteenth-century. Portchester is well known for its castle and the 9-acre site is a scheduled ancient monument.

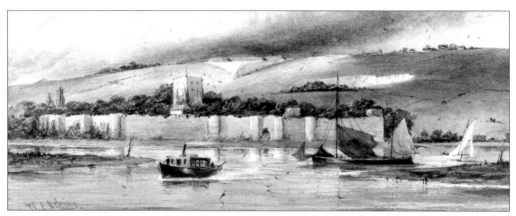

Portchester Castle, 1866 and 2006. (*Above: Westbury Manor Museum/Below: Tim Saunders*)

The site of the castle was fortified using flint quarried from Portsdown Hill in the late third century by Roman sea captain Marcus Aurelius Carausius. It was first used as a base by the Romans. From the middle of the fifth century until the end of the ninth century it became a Saxon settlement. In the early twelfth century an actual castle was first built here. It became a useful stronghold and its proximity to the harbour made it ideal for channel crossings. Henry I often used the castle and it became a safe depository for treasury bullion. The castle was captured by the French in 1215 during the barons rebellion against King John and its demolition was ordered by his successor, Henry III. It was retained, however, and used to store munitions for wars against France. Throughout the following Hundred Years War the castle was on the front line and repelled raids from across the channel. When Richard II made peace with France in 1396 he rebuilt much of the castle, transforming part of it into a palace. Henry V used Portchester as a departure point for Agincourt in 1415, but thereafter it was superseded by Portsmouth and saw little action. It was used to house troops in the Civil War and prisoners of war during the Napoleonic Wars. Graffiti from the late eighteenth and early nineteenth centuries can still be seen. The last royal visit was in 1601 when Queen Elizabeth I held court there.

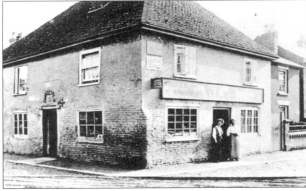

Nineteenth-century Portchester.
(*Westbury Manor Museum*)

This old photograph, the original of which is very tiny, shows a property in need of much repair. Today there is a scattering of new properties in West Street, several of which have replaced some of these old buildings. (*Westbury Manor Museum*)

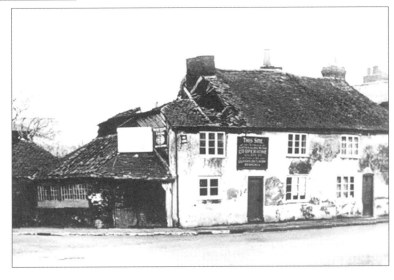

The Castle Bakery Tea Rooms, 2006.
The tea rooms are entered by carefully walking down the steps behind the iron railings.
They are just round the corner from the castle and must enjoy a good trade from visitors.
(Tim Saunders)

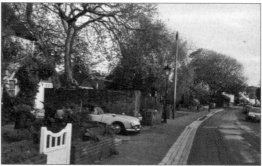

Portchester, 2006.
(Tim Saunders)

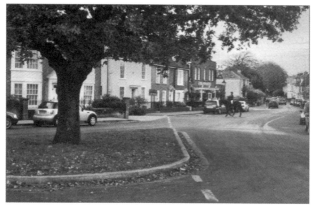

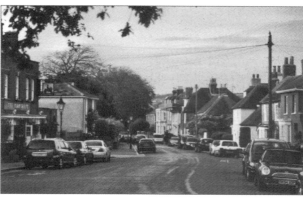

Southwick is an estate village. Until 1988 it was owned by the Borthwick-Norton family. When Mrs Eva Borthwick-Norton died she left the entire estate to her nephew, Mr Thistlethwaite. The estate still owns virtually everything in the parish. Southwick, 2006.
(*Tim Saunders*)

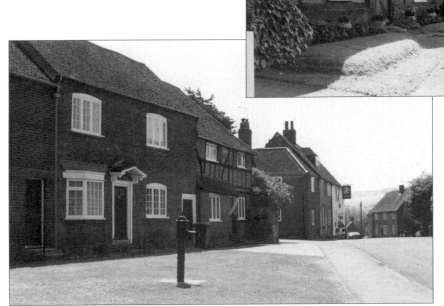

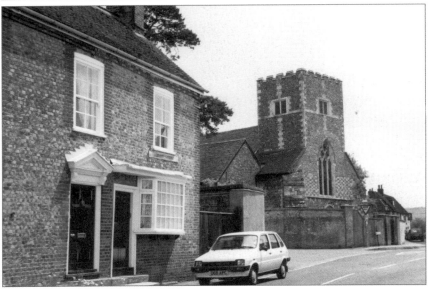

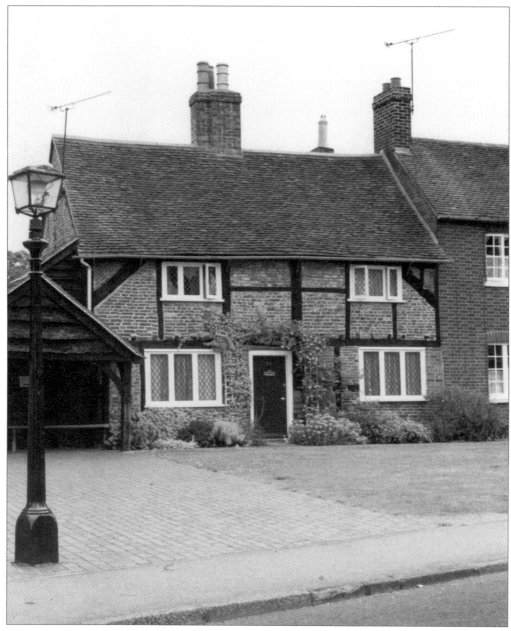

At the heart of the sleepy historic village of Southwick stands Southwick Brewhouse, a scheduled ancient monument. This early Victorian brewery last saw active service in 1957 when master brewer Dick Olding hung up his keys for the last time at the ripe old age of 81. It was he who had crafted the ales to supply the Golden Lion public house next door, where Generals Eisenhower and Montgomery took sustenance as they planned the D-Day landings in 1944.

The brewhouse remains intact and complete in every aspect. New life is being breathed into the building as it re-opens as a shop that boasts a comprehensive range of beers and ciders of local, national and international distinction. *(Tim Saunders)*

Stubbington, *c*. 1910. Stubbington lies to the south of Fareham, once a favoured landing place for contraband goods. It is separated from the main part of the town by open farmland. In 1912 Stubbington consisted of a few dozen cottages and farms on flat countryside. Over the years, as a result of damage sustained during the Second World War and also because of an intensive building programme, the village has undergone a complete transformation. (*Westbury Manor Museum*)

Stubbington, 2006. 'It's like a bomb has been dropped on Stubbington and it has had to be rebuilt on the cheap,' commented one local. He was not far wrong. When comparing old and new photographs it certainly does seem to be two different places. What was once a graceful little village on the edge of Lee-on-the-Solent is now somewhere you drive past quickly. The buildings are ugly and there is an air of depression. (*Tim Saunders*)

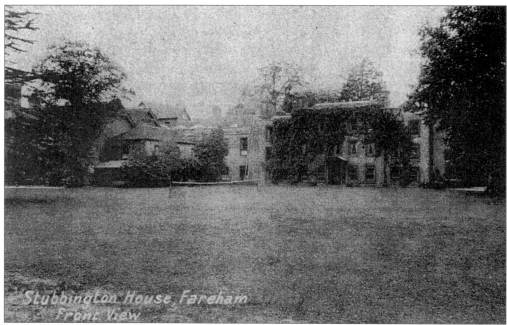

Stubbington House was an attractive Queen Anne building. It stood for more than 250 years in Stubbington Lane, just south of the village centre, where the tennis courts and public library are today. It was a school for some 120 years. The school was started by the Revd William Foster in 1841 and became what was probably the most famous boys' prep school in the county. Aged 13, Robert Scott (Scott of the Antarctic) briefly attended this prestigious school – then the recognised place for coaching towards a naval cadetship.

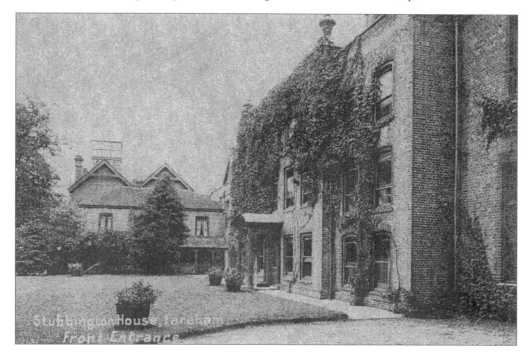

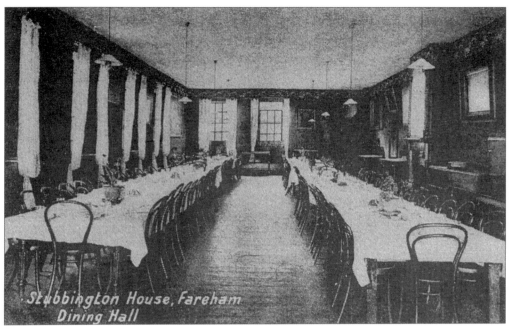

Other notable naval figures attended, for instance Admiral of the Fleet Viscount Cunningham of Hyndhope and Rear-Admiral Sir Anthony Miers. Another famous old boy was Sir Thomas Sopwith who later went on to produce some stunning aircraft. The school relocated to Ascot, Berkshire, in the 1960s and has now shut. Stubbington House was demolished in 1967. These four images are of Stubbington House School in the early twentieth century. *(Westbury Manor Museum)*

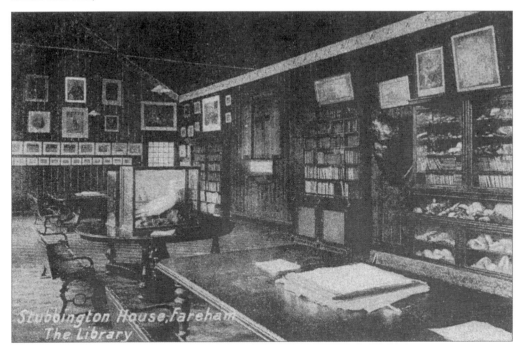

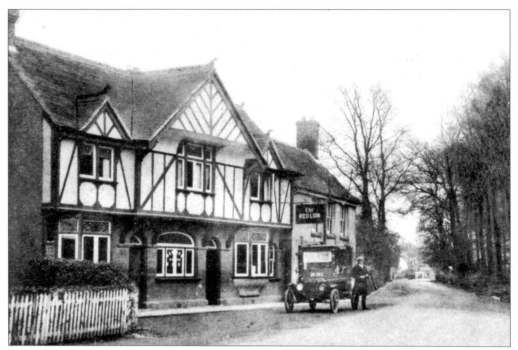

Red Lion Hotel, Stubbington, *c.* 1910 *(Westbury Manor Museum)*

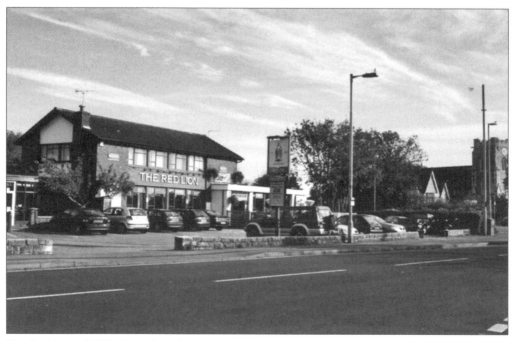

The Red Lion, 2006. *(Tim Saunders)*

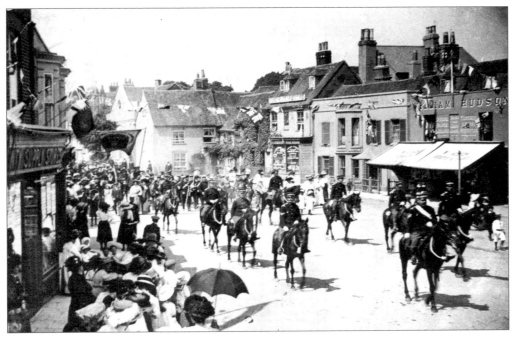

Titchfield local militia, *c.* 1910. *(Westbury Manor Museum)*

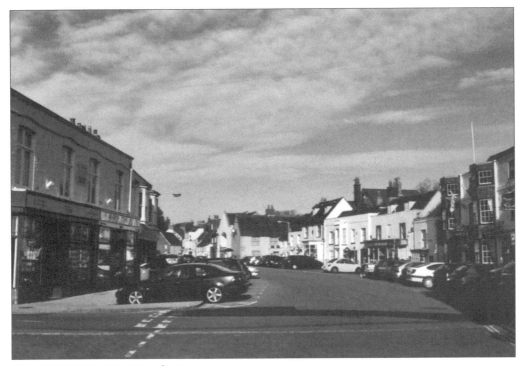

Titchfield, 2006. *(Tim Saunders)*

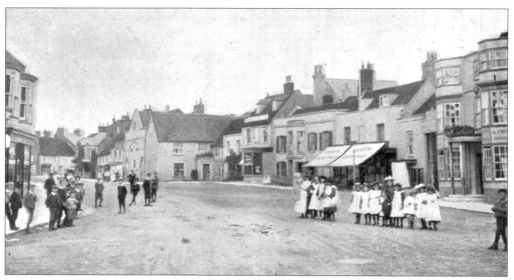

The Square, Titchfield, *c.* 1905. Titchfield lies between Southampton and Portsmouth. There was a market here in Norman times and in 1232 an abbey was founded. At the Dissolution it was in the hands of Thomas Wriothesley, later Earl of Southampton, one of Henry VIII's agents who disposed of monastic possessions. He converted the abbey into a mansion for himself, later known as Place House. There were four earls of Southampton; the third was Shakespeare's patron. *(Westbury Manor Museum)* *Right: The* Earl of Southampton, 1594. *(Westbury Manor Museum)*

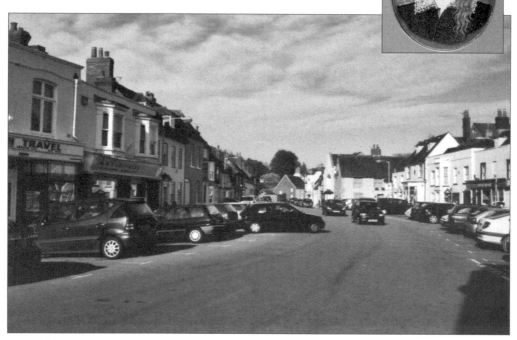

Titchfield, 2006. *(Tim Saunders)*

Place House, Titchfield,
c. 1900. *(Westbury Manor Museum)*

Lady Betty Delmé by Joshua Reynolds, 1777. Lady Betty Delmé's looks made her a beauty of Queen Charlotte's court. With her children she sat for Joshua Reynolds in April and June 1777. Reynolds was the first president of the Royal Society. Her picture hung in the London Gallery, then in Cams Hall, and was finally taken to America. *(Westbury Manor Museum)*

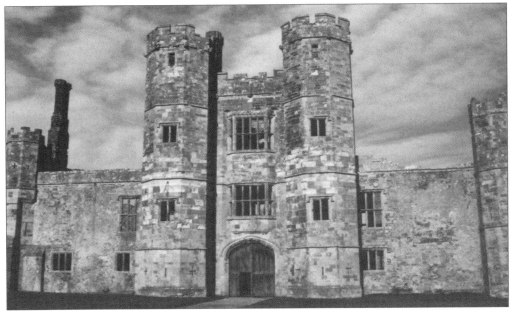

Place House, 2006. The grounds are no longer overgrown. Peter Delmé bought Place House in 1741. He was influential in London societies such as the Academy of Sciences and the Royal Society of London. He died aged 59 in 1770, either from an apoplectic fit or because he shot himself owing to bad finances. The latter is unfortunately plausible. The next Lord of Titchfield Manor was another Peter Delmé, who married into nobility. His wife was Lady Elizabeth Howard, third daughter of the fourth Earl of Carlisle and one of the ladies-in-waiting to Queen Charlotte, wife of George III. Lady Betty did not much care for Place House; she must have found the village remote and not served by the best roads. *(Tim Saunders)*

In the 1980s you could have bought a property in Titchfield for just £64,000. That same property today would cost nearer £400,000. (*Tim Saunders*)

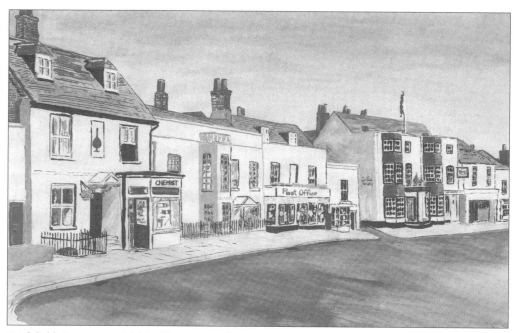

Titchfield Square, *c.* 1990. The sixteenth-century author Edmund Spenser, famous for his book *The Faerie Queene*, lived in Titchfield. From Titchfield there is a lovely view of the 558ft Spinnaker tower at Portsmouth. This is the tallest public viewing tower in the UK and is made of concrete, steel and composite. It is a £35 million Millennium Commission-sponsored project. A man was trapped in the lift of the tower for more than an hour on the day the troubled structure finally opened to the public. (*Westbury Manor Museum*)

Old Tannery sheds Wallington, *c. 1930*. Two
ARP officers inspect the area. During the Second
World War the tannery buildings were taken
over by the ARP. Little is left of them now.
(Westbury Manor Museum)

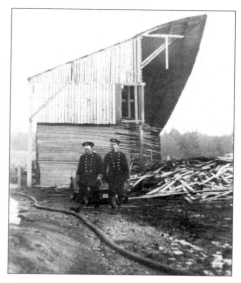

There were three important industries in
Wallington: Mr Stares' potteries; the brewery
owned by the Saunders family (which shut in
1944); and the tanneries which converted as
much as 250 hides a week into leather goods.
Fort Wallington was built between 1861 and
1874.

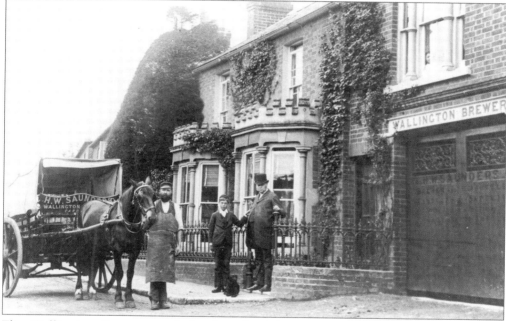

The Wallington Brewery and the Saunders' horse and cart, *c. 1900*. Presumably
Mr Saunders is the chap wearing the top hat and tails and standing on the steps with his
son. The Saunders family purchased the brewery in 1867. Probably the best-known business
in Wallington today is Lucketts Travel. The company was formed in 1926 by Harry Luckett,
the current chairman's father. It was a haulage and storage business, and they also kept
chickens and other farmyard animals. David Luckett joined the company in 1963 and took
over in 1966 when Harry died. David purchased the company's first coach in 1976,
choosing to drive it himself. By the mid-1980s the coach fleet outnumbered the lorries. The
third generation of Lucketts joined the company, Steve in 1983 and Ian in 1985, and since
then the company has grown to a turnover of over £4.5 million per year. It employs over
seventy people. *(Westbury Manor Museum)*

Warsash's clock tower, 2006. Warsash was a small timber and fishing port at the mouth of the River Hamble, and also a landing-place for the Hamble–Warsash ferry. The area became notable in the nineteenth century for its strawberry growing. At the crossroads in the centre of the village is this unusual clock tower built in about 1900. (*Tim Saunders*)

A row of terraced cottages in Warsash, 2006. To the far right is the clock tower. For over sixty years Warsash Maritime Academy has provided first-class training, consultancy and research to the international shipping and offshore oil industries. The centre provides certification programmes from cadetships to Class 1 for both deck and engineer officers and short courses to develop skills such as fire fighting and sea survival. Warsash pioneered the use of bridge and engine room simulators for higher level training, and the Liquid Cargo Operations Simulator (which is the most advanced of its kind) was developed in house. Their manned model ship handling training facility is the only one in the UK, and one of the few in the world. Warsash Maritime Academy is owned by Southampton Solent University. (*Tim Saunders*)

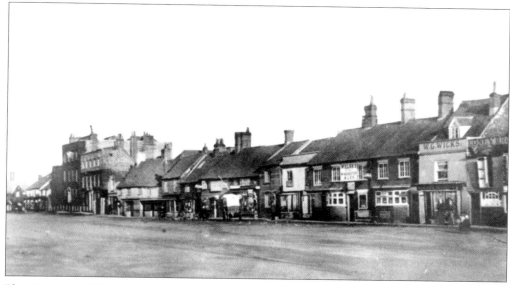

The Square at Wickham, *c.* 1900. William of Wykeham was born here in 1324. Probably Wickham's most famous individual, from 1367 he was the Bishop of Winchester. He remodelled Winchester Cathedral's nave to the design of William Wynford – one of the great medieval architects. Wykeham founded Winchester College and New College, Oxford. (*Westbury Manor Museum*)

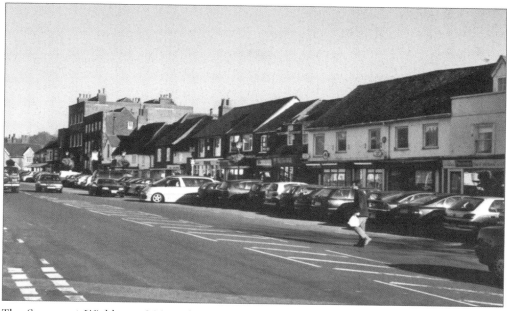

The Square at Wickham, 2006. This virtually identical shot shows how the buildings have remained almost unchanged but many lack chimneys and there are far too many vehicles. (*Tim Saunders*)

Paddons Almshouses, 2006. The Paddon Memorial Almshouses were erected in 1850 by Joseph Paddon for two almspeople in memory of his wife. Almshouses, as the name suggests, were guesthouses where poor travellers as well as the sick and old, could find shelter. They were also called maisons-dieu and bedehouses. Almshouses can be found in many towns and cities. Restored in 1963, in 2006 these almshouses were once again being renovated. (*Tim Saunders*)

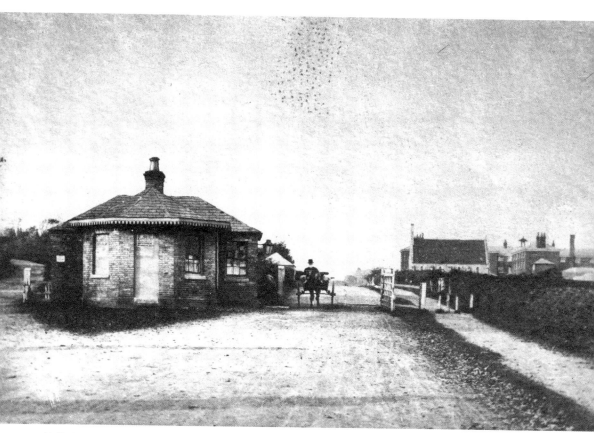

Toll Gate, Wickham, before 1914. If you leave Fareham via High Street and turn left at the roundabout as if heading to Wickham you approach Old Turnpike Garage. This rather uncared-for building, which is now home to a tyre and battery fitter, has more history to it than you might at first imagine. Perhaps this bearded gentleman driving his horse and cart is heading towards Fareham. It appears that he is wearing a top hat and tails suggesting that it might be a Sunday and that he might be heading for church. *(Westbury Manor Museum)*

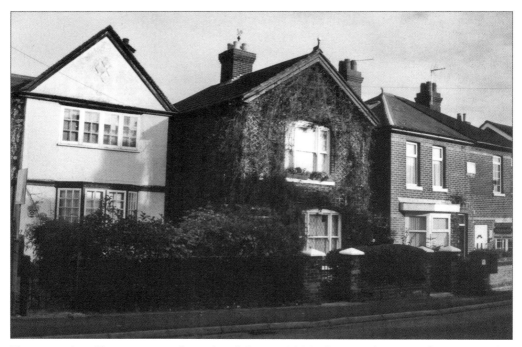

These are the old cottages on the right of the pre-1914 photograph, pictured in 2006. This small terrace was built in 1902 and is still standing today. *(Tim Saunders)*

Toll Gate Wickham, Old Turnpike Garage, 2006. *(Tim Saunders)*

A view of the tollgate on a Christmas card, 1952. *(Westbury Manor Museum)*

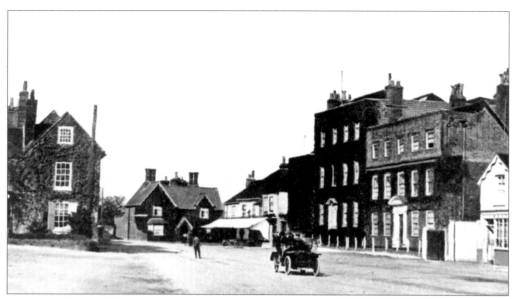

A postcard view showing Wickham, *c.* 1920. A lone motor car makes its way through Wickham and as it does so is watched by an interested onlooker. The fortunate driver at this time would not have had to negotiate traffic jams or traffic wardens. His worries would have been reliability and availability of petrol. *(Westbury Manor Museum)*

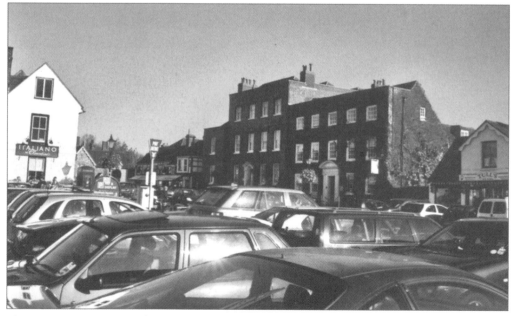

The same spot, 2006. The curse of the mass-produced motor car prevails. Wouldn't an underground car park be marvellous? The council recently started charging for car parking here – 10p for an hour. Pleasingly, once again, the structure of the buildings remains virtually unchanged. A noticeable difference is that the building that is now an Italian restaurant (on the left of the photograph) does not have any ivy growing over it as it did a hundred years ago.*(Tim Saunders)*

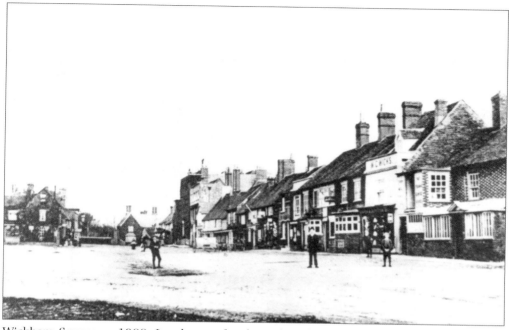

Wickham Square, *c.* 1900. Locals pose for that relatively new invention, the Box Brownie. (*Westbury Manor Museum*)

A Box Brownie. The first Brownie, introduced in 1900, was a very basic cardboard box camera with a simple meniscus lens that took 2¼-inch square pictures on 117 roll film. (*Tim Saunders*)

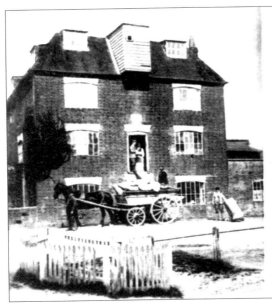

THE CHESAPEAKE MILL.
WICKHAM, HANTS.

A place of pilgrimage of all American visitors.

The interior of this Mill is noted as being the remains of the famous U.S. Frigate « Chesapeake » which fought the « Shannon » in 1813, outside Boston Harbour, one of the most famous naval duels on record. The « Chesapeake » on arriving in England was dismantled and bought by John Prior, a former owner of this mill and its beams, just as they were on the ship — used as rafters for the present mill, the shot holes being still visible.

(Copyright)

Chesapeake Mill, c. 1820. (*Westbury Manor Museum*)

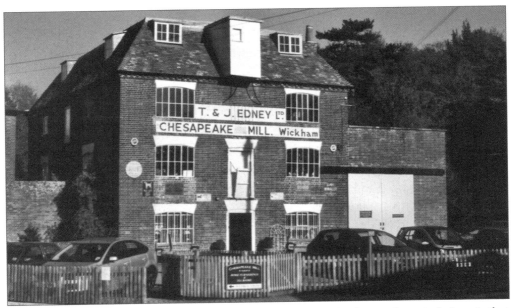

Chesapeake Mill, 2006. There are some noticeable changes. The first and most obvious is that there was no company name written on the building when the first photo was taken; it now reads 'T & J EDNEY LTD CHESAPEAKE MILL, Wickham'. Edward Edney became the miller in 1878 and in 1919 T.E. and J.H. Edney purchased the mill from the Garniers, who had been the owners for the past fifty-three years. It remained in the Edney family until it closed in 1991. The central door where the two men are standing in the first photograph, has now become a window. The main entrance to the building is gained by the front door beneath this window. Generally the building remains unaltered. To the right, large double doors have been fitted as a means of getting large items in and out of the building. (*Tim Saunders*)

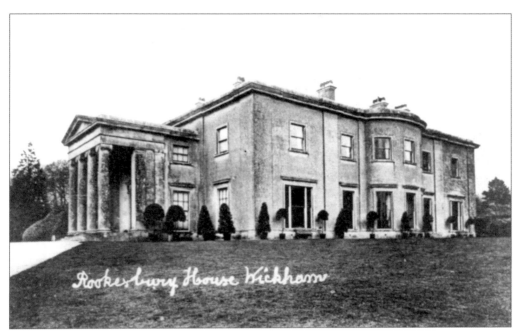

Rookesbury House. *(Westbury Manor Museum)*

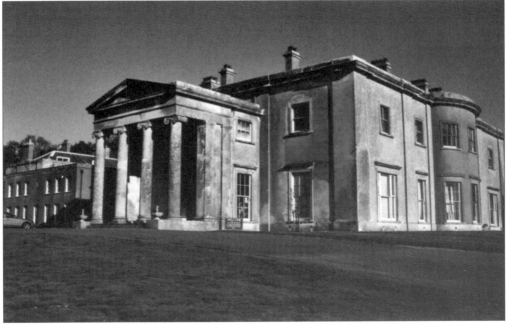

There has been no change to the actual building but there has been a change of use, 2006. Now the home of Rookesbury Park School, the nineteenth-century Rookesbury House is a large Roman cement-faced building. It has a wide and deep projecting portico of four Ionic columns on a plinth. Rookesbury Park School opened in 1929. In the 1930s the actress Belinda Lee, famous for her lead role in *Aphrodite, Goddess of Love*, attended the school. *(Tim Saunders)*

Westbury Manor Museum is a splendid resource in the centre of Fareham. It offers fabulous facilities for research and there are regular displays showing Fareham's past.

New family friendly timeline gallery.
New look coffee shop.
Refurbished exhibitions gallery.
Great new resource room.

Westbury Manor Museum
84 West Street
Fareham
Hampshire
PO16 0JJ

Tel. 01329 824895
www.hants.gov.uk/museum/westbury

Admission free.